DRAWING DRAGONS

AND THOSE WHO HUNT THEM

DRAWING DRAGONS

AND THOSE WHO HUNT THEM

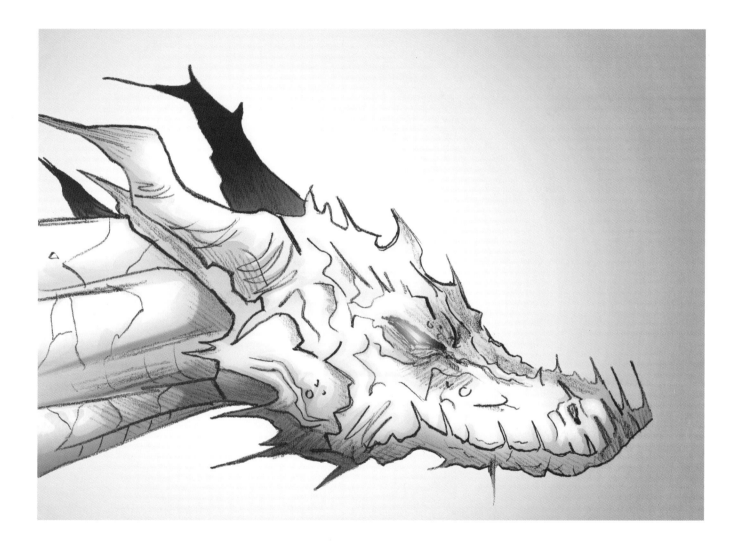

CHRISTOPHER HART

WATSON-GUPTILL PUBLICATIONS/NEW YORK

Executive Editor: Candace Raney
Art Director: Julie Duquet
Designer: Kapo Ng@A-Men Project
Senior Production Manager: Alyn Evans

Color by Richard and Tanya Horie, with the exception of
pages 5, 8, 12, 53, 72, 76, and 98 by MADA Design, Inc.

Special thanks to Bob Fillie of Graphiti Design, Inc., for
breaking the borders, making the gatefolds work, and
cleaning so many things up. —AP

First published in 2007 by Watson-Guptill Publications
Nielsen Business Media, a division of The Nielsen Company.
770 Broadway
New York, NY 10003
www.watsonguptill.com

Library of Congress Cataloging-in-Publication Data
Hart, Christopher.
 Drawing dragons and those who hunt them / Christopher Hart.
 p. cm.
 Includes index.
 ISBN-13: 978-0-8230-0612-0 (pbk.)
 ISBN-10: 0-8230-0612-3 (pbk.)
 1. Dragons in art. 2. Hunters in art. 3. Drawing–Technique. I. Title.
 NC825.D72H37 2007
 704.9'47--dc22

 2007000426

Printed in Singapore

1 2 3 4 5 6 7 8 9 / 15 14 13 12 11 10 09 08 07

To Candace Raney, who has helped me slay a lot of dragons

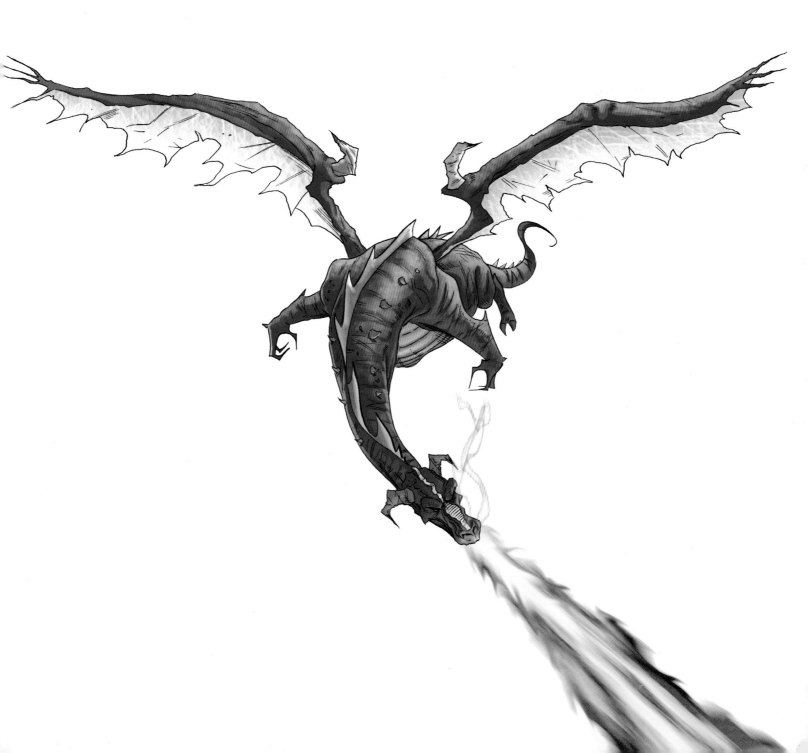

CONTENTS

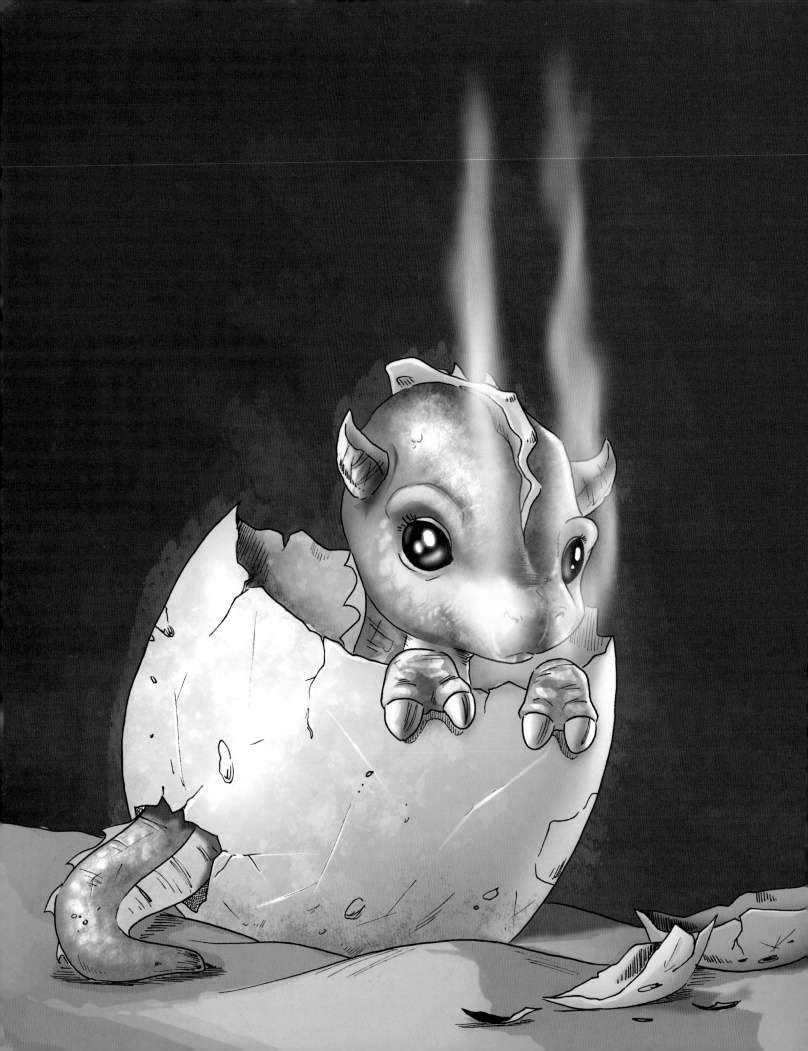

INTRODUCTION

Dragons are the supreme rulers of the fantasy world. These fire-breathing beasts have captivated us with their titanic battles in a world not our own. The time for dragons is upon us once again. They have never been so popular as they are now. They are everywhere: in best-selling, illustrated books; graphic novels; comics; anime; computer games; and movies.

Dragons come in all shapes and sizes. There are rare and exotic breeds, such as the many-headed hydra, the unicorn dragon, the beast type, the thorn dragon, and the flier. The dark world of the dragon is populated by other strange creatures, as well: astonishing species, such as the voracious hell worms, the giant lizards, and others, which early people learned to domesticate and use for transportation in a primitive world.

Dragons are complex and mysterious creatures—merciless to their enemies and, yet, kind and nurturing to their young, which they raise in a cohesive social network. Fear them? Absolutely. But revile them? Not necessarily. Some may even admire them for their magnificence. And yet, they are the most ruthless, efficient killing machines ever to walk the face of the Earth.

This book will guide you, step by step—and with expert art instruction—through drawing the dragon head and body, understanding dragon anatomy and the mechanics of breathing fire, staging battle scenes, and much more. You'll learn about primitive man's epic struggle for survival against the ultimate beast in the darkest of times. Some men were heroic. Others chose to serve the dragon. And the female warriors were beautiful fighters who knew no fear. Learn to draw all of them with the heart-pounding excitement that creates memorable fantasy illustrations. Dragons were meant to engage humans in epic battles for survival. You were meant to draw them. Pick up your pencil. The battle is about to begin.

I

THE DRAGON HEAD

From the beginning of time, humans and dragons have been locked in a battle of life and death. Humans were no match for the awesome strength and size of dragons. Obviously, humans would not long survive. And yet, somehow, they did. As we travel this rocky and dangerous path together, studying and drawing this fantastic, lesser-known history of man, we'll witness the amazing legacy that has been handed down to each of us, from these earliest generations: the indomitable human spirit. And even that was barely enough. In fact, some say the beast lives still . . .

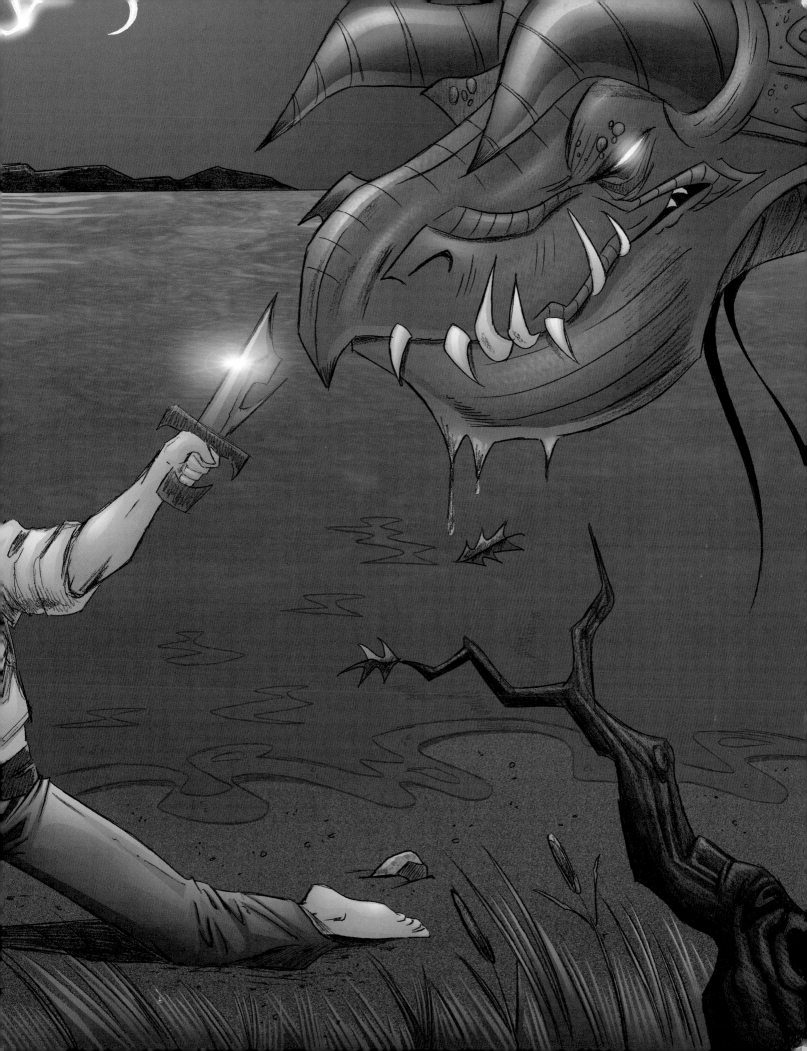

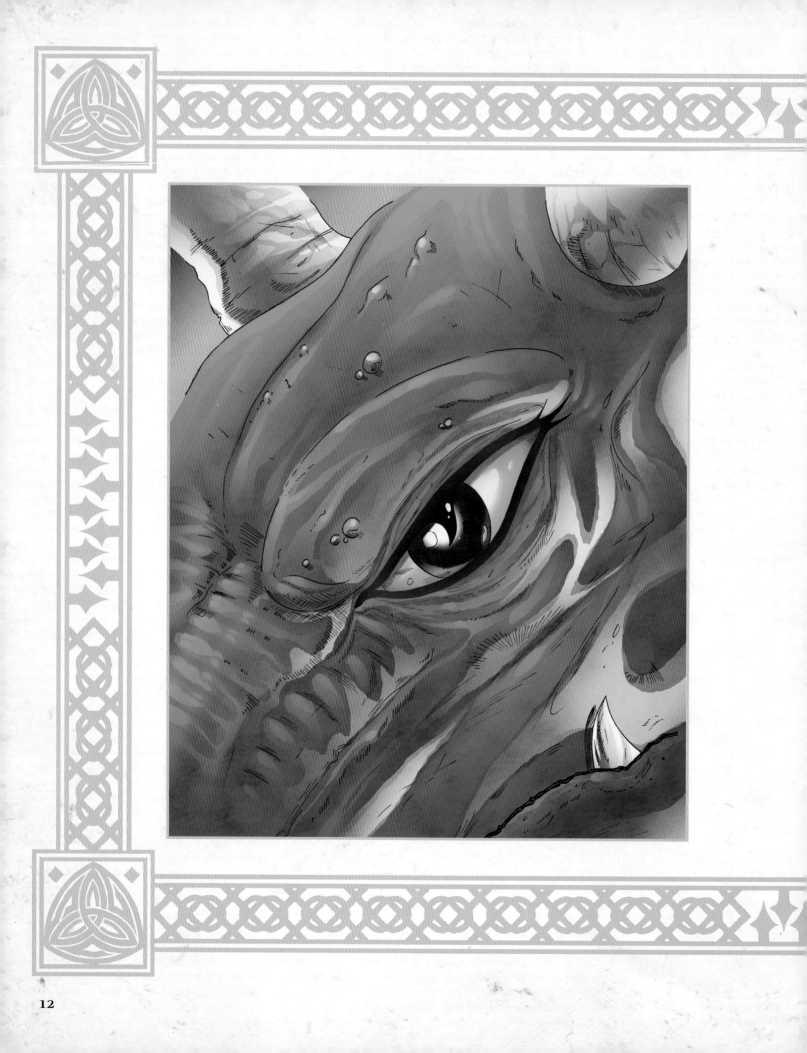

THE EYE OF THE DRAGON

As we begin our journey into the world of the dragon, a word of caution: Never look directly into a dragon's eye. The creature will manipulate its gaze to hypnotize its prey—humans. The eye is so luminous that a person is in danger of becoming transfixed by it. If that happens, the eye is often, unfortunately, the last thing that person sees.

However, as an artist, as you pick up your pad, don't allow your pity for your poor human subjects—or your own natural instinct to flee a dragon—cause *you* to look away. As an artist, you must overcome your emotions and try to capture, on paper, the essence of the terrible beast. Let its awesome power flow through your pencil and out onto your drawings. But be warned: Do not remain to stare.

HOW DRAGONS SEE THE WORLD

The dragon has poor vision during the day but excellent night vision. Dragon sight is based on a special heat sensor that picks up body warmth. Contrary to popular belief, the dragon isn't particularly sensitive to motion. It doesn't matter whether you're moving or not. Your only chance of not being spotted is if your core temperature is *exactly* the same as the atmospheric temperature. If it isn't, the dragon will see the difference—and see you.

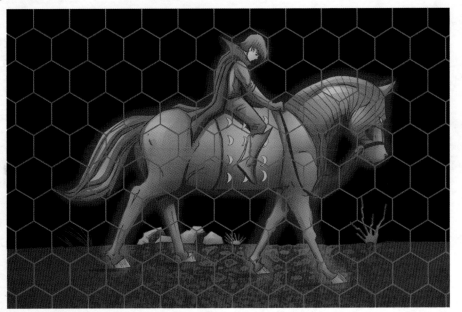

THE DRAGON SKULL

A dragon's head is a fancy-looking piece of work. It has horns, scales, ridges, spikes, bumps, and crevices. Don't attempt to draw all of the exciting, craggy parts first. You can achieve a much better result by first focusing on the basic construction of the head. This, combined with a simple understanding of the bony contours of the interior of the face, will yield greater success. The skull is pronounced on this epic beast, and its features and angles show through to the surface.

So, our first stop will be the dragon's skull. When drawing the head, everything starts with the shape of the skull. For all its visual extravagance, a dragon is, at its core, just another animal. Try to view its skull simply as that—another animal skull.

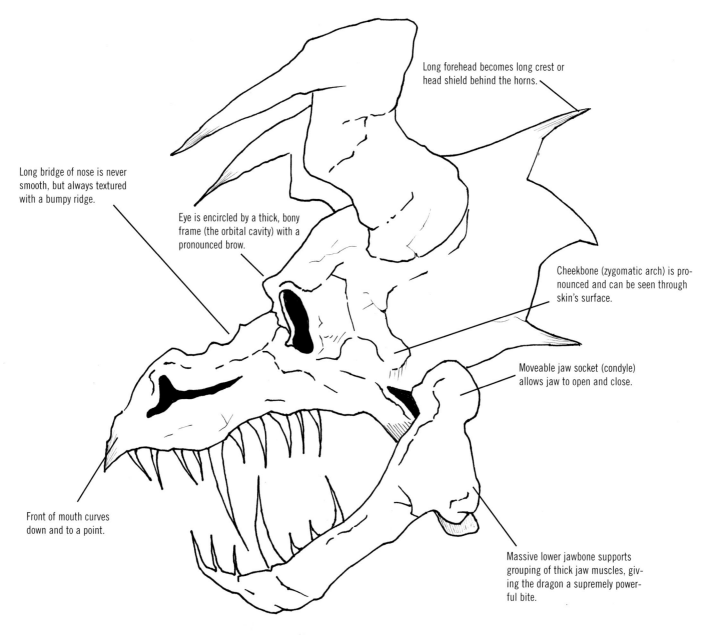

Long forehead becomes long crest or head shield behind the horns.

Long bridge of nose is never smooth, but always textured with a bumpy ridge.

Eye is encircled by a thick, bony frame (the orbital cavity) with a pronounced brow.

Cheekbone (zygomatic arch) is pronounced and can be seen through skin's surface.

Moveable jaw socket (condyle) allows jaw to open and close.

Front of mouth curves down and to a point.

Massive lower jawbone supports grouping of thick jaw muscles, giving the dragon a supremely powerful bite.

The dragon can open its jaw very, very wide indeed. Bad news for some.

14

PATHWAY OF FIRE

We'll get to the real nitty-gritty of fire-breathing on page 32, but there are some things you should know about the skull as it relates to fire-breathing. The dragon's skull has ingeniously evolved over the years to become a superefficient flamethrower. The combustible "liquid" is squeezed through a single canal in the middle of the throat, which narrows considerably. This narrowing forces the flame to gather speed and destructive power. The dragon may also eject flame through its nostrils, but only when its mouth is closed. The combustible liquid is then diverted into the two smaller nasal passages. After the fire is released and sprayed, the excess liquid drains off into the sinus areas so that the dragon always maintains a ready reserve.

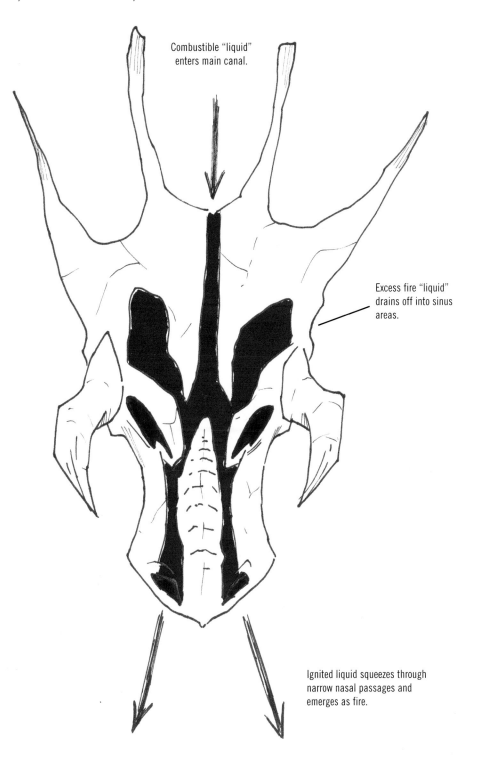

Combustible "liquid" enters main canal.

Excess fire "liquid" drains off into sinus areas.

Ignited liquid squeezes through narrow nasal passages and emerges as fire.

SURFACE MAP OF THE HEAD

Once you've familiarized yourself with the basic outline and structure of the dragon skull, you can cover it with a sheet of tightly pulled skin. Ridges, creases, and webbing will begin to appear, which will give the dragon its crusty character.

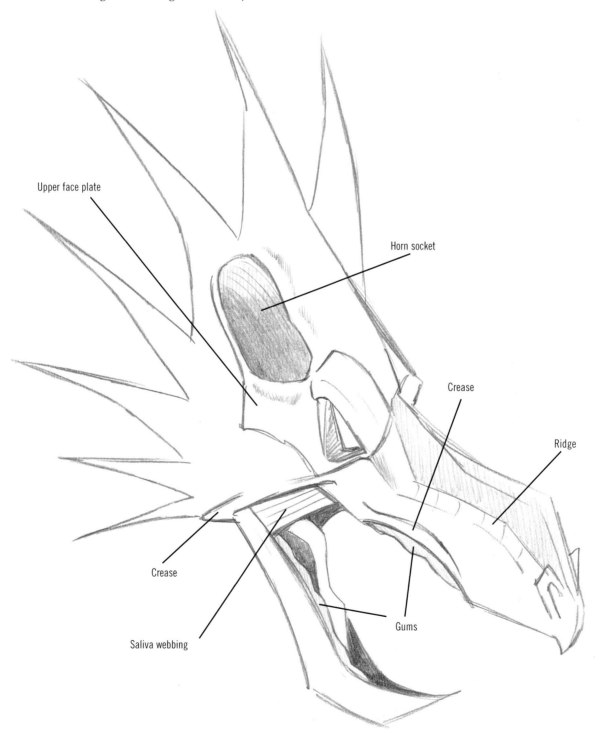

Upper face plate

Horn socket

Crease

Ridge

Crease

Gums

Saliva webbing

16

Note that the tongue is long and thin, traveling the length of the mouth. Note, too, that dragon saliva is extremely thick and sticky, and often stretches between the upper and lower jawbones as the mouth opens, rather than breaking apart. Dragons, unlike other reptiles, don't have venom. They don't need it.

THE DRAGON HEAD-ON

It's important, as an aspiring fantasy illustrator, to become comfortable with your subject matter. You don't want to design a scene based on, and limited by, the fact that you can only draw a dragon in a profile, for example. That doesn't give you enough options. This section will open up possibilities for you. We're going to draw dragons from many different—and dramatic—angles. These angles aren't just for exercise; they are effective, dramatic poses you can use in your own dragon illustrations. We'll take this step by step, with no major jumps from one step to the next, so that you won't get left behind.

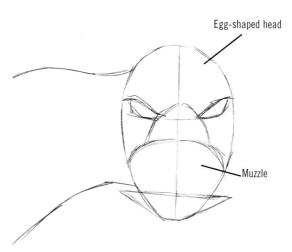

The dragon's stare is absolutely, 100 percent dead-on straight and doesn't waver. To achieve this look in your drawing, it's important to start by focusing carefully on the two main guidelines, making sure they are perpendicular to each other. The vertical one indicates the center of the head, and the eyes rest on the horizontal one. The outlines of the sides of the head should be symmetrical.

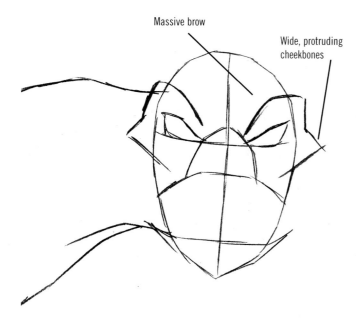

Sketch in the bony structures around the eyes.

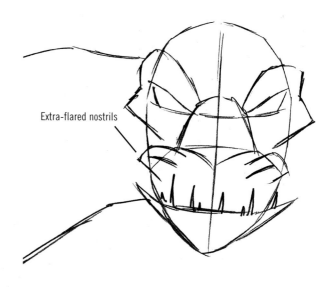

As you sketch in the muzzle details, indicate a dip in the center.

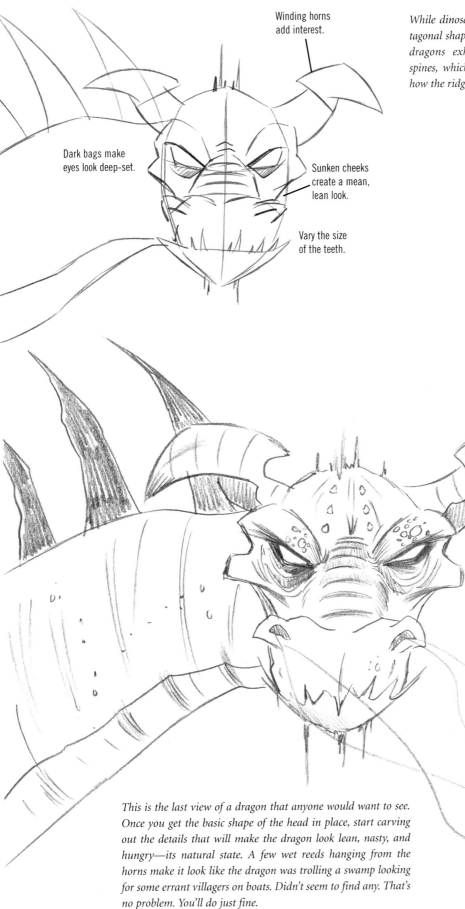

Winding horns add interest.

Dark bags make eyes look deep-set.

Sunken cheeks create a mean, lean look.

Vary the size of the teeth.

While dinosaurs have flattened (and often pentagonal shaped) plates on their backs and necks, dragons exhibit dangerously pointed dorsal spines, which trail off in a row. Also note here how the ridged snout begins above the eyes.

This is the last view of a dragon that anyone would want to see. Once you get the basic shape of the head in place, start carving out the details that will make the dragon look lean, nasty, and hungry—its natural state. A few wet reeds hanging from the horns make it look like the dragon was trolling a swamp looking for some errant villagers on boats. Didn't seem to find any. That's no problem. You'll do just fine.

A SIDELONG GLANCE

Here is a particularly evil look. With head held low, the dragon appears a brooding animal. It surveys its territory for anything that might arouse its interest. With nose pointed toward the ground, the dragon looks up from under its thick eyelids with a sinister stare. Observe closely, and you'll see that the top of the pupil is cut off by the line of the eyelid.

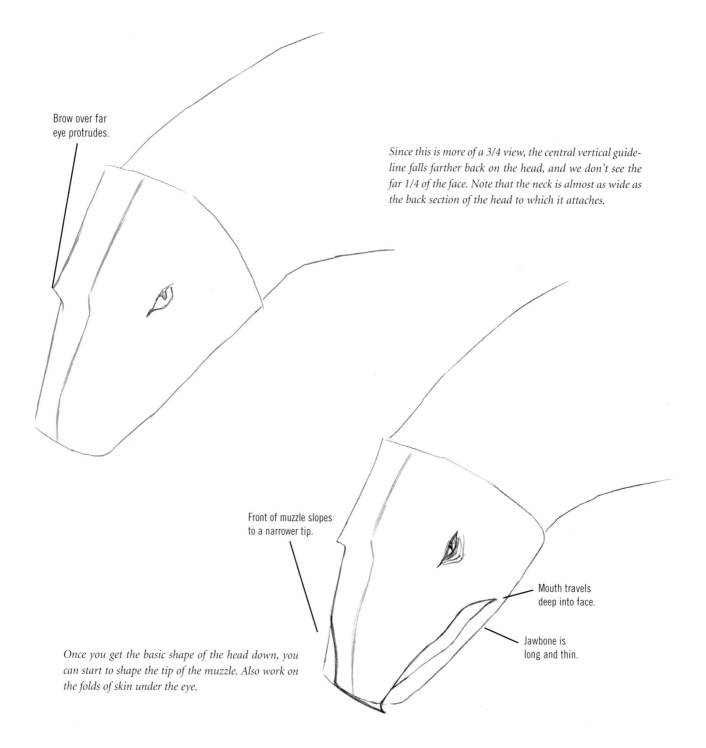

Brow over far
eye protrudes.

Since this is more of a 3/4 view, the central vertical guideline falls farther back on the head, and we don't see the far 1/4 of the face. Note that the neck is almost as wide as the back section of the head to which it attaches.

Front of muzzle slopes
to a narrower tip.

Mouth travels
deep into face.

Jawbone is
long and thin.

Once you get the basic shape of the head down, you can start to shape the tip of the muzzle. Also work on the folds of skin under the eye.

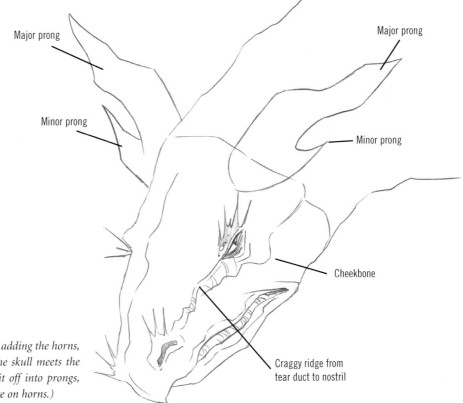

Attenutated spikes appear on eyebrows and nostrils.

To further develop the eye, add attenuated spikes and some craggy, wartlike textures. Indicate the ridge that travels from the eye to the nostril, where more spikes appear. Start to sketch in the teeth.

Major prong

Major prong

Minor prong

Minor prong

Cheekbone

Craggy ridge from tear duct to nostril

At this stage, you're fleshing out the details and adding the horns, which attach to the head where the back of the skull meets the start of the neck. Note that the horns can split off into prongs, which should vary in size. (See page 28 for more on horns.)

Split crest in forehead

Adding shading to more distant parts of the dragon helps convey a sense of depth. Note the added head shields and the spines running down the back of the neck. These are both standard dragon accoutrements.

INKING DRAWINGS

When inking a drawing (i.e., going over your finished pencil drawing with ink), use a darker ink line for the outline than for the interior lines. Not all ink lines have to be restrictive and tight. They can also be expressive when drawn quickly and energetically, similar to a sketchy pencil line.

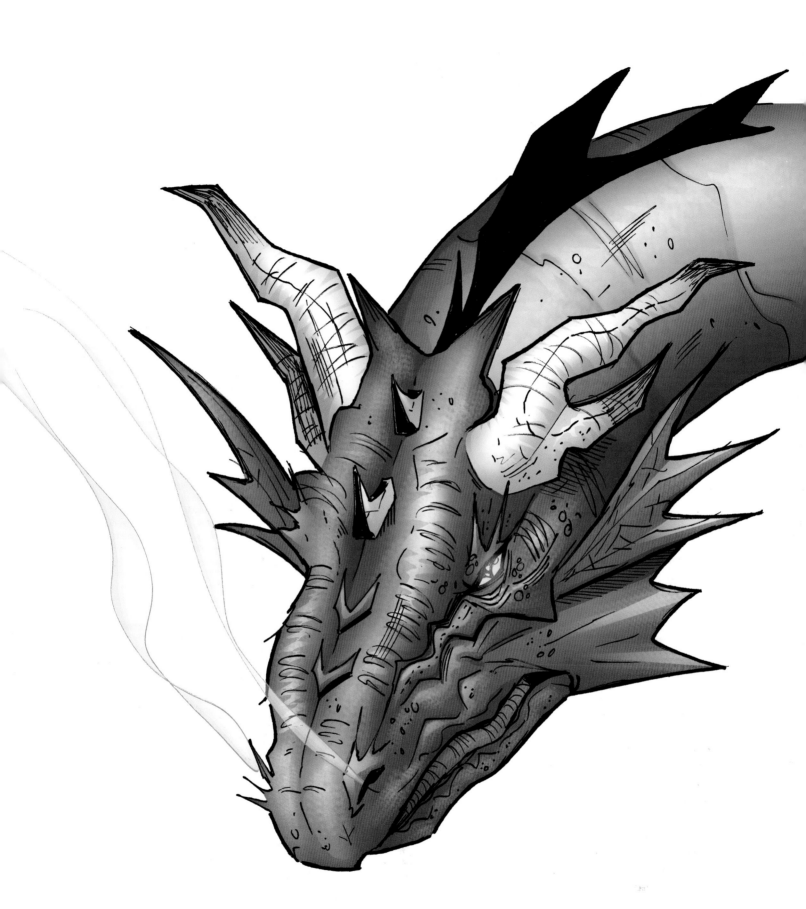

A bold ink line on a powerful character cries out for color treatment.

THE STEALTH OF THE DRAGON

In the time of dragons, bands of hunters had to track prey for days before catching something to bring back as food to the village. They would stop as they heard the distress call of the ram's horn coming from their village. Torn about whether to heed this warning and return to the village empty-handed, letting wives and children go hungry, or to continue the hunt, most often, they would bravely press on, and the villagers would go hungry. But not the dragon. . . . The dragon could stay frozen in one position for hours, waiting patiently for its prey. Since dragons could sleep while standing, some villagers often assumed that dragons that remained still for hours had dozed off. Groups of people would seize the moment to pass by the dragon or cross a bridge to safety. It was a grim mistake.

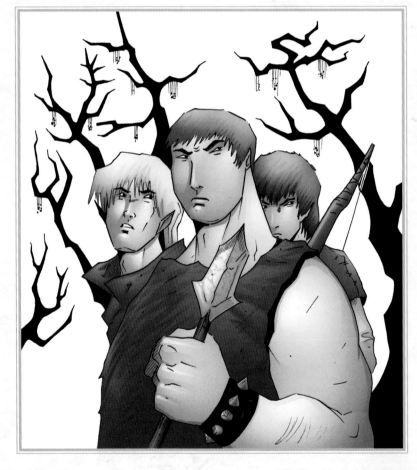

THE DRAGON IN STEALTH MODE

Dragons use their long necks to gain height and survey the landscape. And, as we've just learned, they can do this for indefinite periods of time. This pose carves out a strong profile and a striking S curve to the neck, which is both sturdy and elegant. Never draw a perfectly straight neck, as that would be stiff instead of serpentine. The head should be held parallel to the ground during surveillance. And note the low forehead, a characteristic adult dragons share with alligators (although there's no genetic ancestral relationship between the two). Only baby dragons have high foreheads.

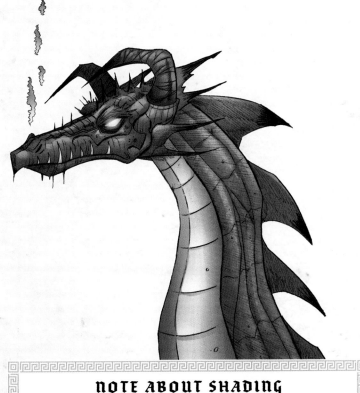

Bony protrusion over far eye

Horns attach at back of skull where neck meets head.

Faceplate

Teeth wrap around muzzle; they aren't straight.

Centerline appears a little past center in a side or 3/4 view.

NOTE ABOUT SHADING

As in the image above, vary the intensity of the shading: Sharp edges are darkest, shadows are medium, and large interior areas of the body are lightly shaded.

When relaxed, the dragon holds its head at a diagonal. Its nose points slightly downward, which in turn crushes the skin of the front of the neck into pronounced folds, articulating each individual neck section. A dragon can sleep in this position quite comfortably. Some even sleep with their eyes open.

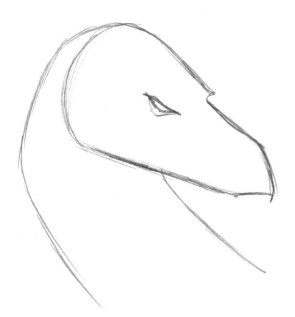

The narrower the angle between the head and neck, the more dramatic the tilt of the head. Keep this in mind as you block out the main structures, which are, basically, a triangle for the head and a cylinder for the neck.

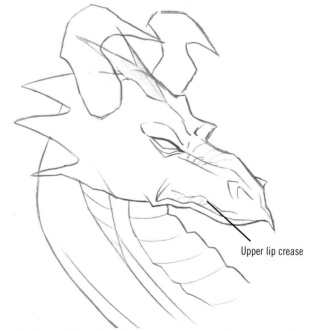

Folds in neck

Start to indicate the ridges on the top of the muzzle and the folds on the front of the neck. Also try to delineate the overall contours of the muzzle. It's not just a simple cone shape.

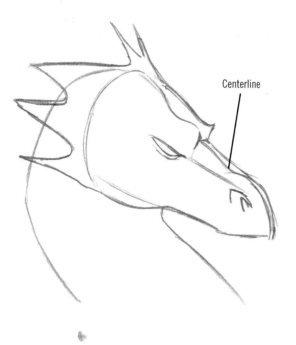

Centerline

Sketch in the centerline, which falls farther back on the head since this is a 3/4 view, and the start of the facial details. Also add spiked faceplates.

Upper lip crease

Determine the position of the horns and start to indicate the reptilian skin texture of the front of the neck.

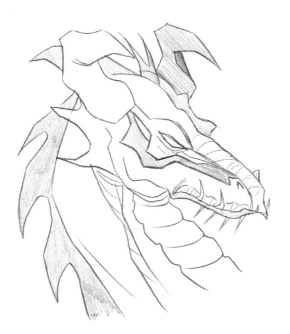

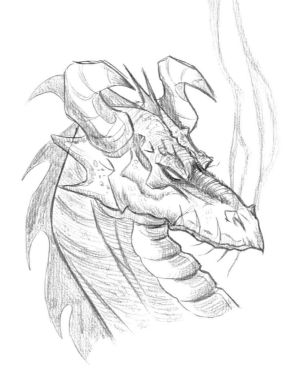

To create a more heavily textured dragon, you can layer the faceplates. I've added a second one (shaded in the drawing above) under the cheekbone.

Color is not the only way to "finish" a drawing. Use of intense pencil shading and linework can add to the drama of your images. When adding shading have the lines "curve around" the forms, indicating their three-dimensionality. Smoke rising from the nostrils is a fun addition; it reminds us of the fiery danger that's always present with a dragon.

IMPORTANT DRAGON DETAILS

Pay attention to these two important dragon features: the muzzle ridging and the faceplate. The green ridge travels from the tear duct to the nostril; you can also extend it to the eyebrow to create an even longer line. The faceplate (in red) often begins at the horn and curves around the orbit of the eye to the cheekbone. It then continues underneath the upper (green) ridge.

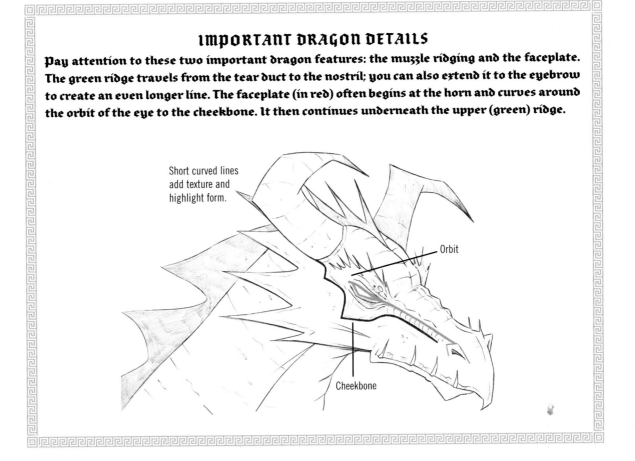

Short curved lines add texture and highlight form.

Orbit

Cheekbone

HORNS

There are many dragon "species." Today, historians who specialize in studying this ancient beast ("dragonophiles") categorize dragons by their specific differences, for example: small fin, long jaw, hanging plates, and so on. The layperson, however, generally refers to a dragon by its type of horn configuration, and there are many. It's often easier to study the horns in silhouette, when you can focus only on the outlines, so we'll start with that, and then compare the silhouettes of the various horn types to the regular drawings of the horns on the facing page.

RAM
These horns wind around in a decreasing helix and are always for-ward-curling.

UNICORN
Named for the third horn on the tip of the muzzle, this is a very rare dragon that resides only in the most northerly mountainous regions. It is said that the unicorn dragon hibernates for long periods, is an excellent parent, and cocoons humans in order to feed them to their dragon young in the lean winter months.

LONG
The long-horn dragon exhibits a sleeker look than the unicorn variety and is a more common type of dragon from lowland areas. The two horns taper back, extending beyond the spikes of the head shield or faceplate. The long-horn never sleeps, constantly guarding its nest.

UPTURNED
These horns curve up toward each other, creating almost a closed loop. This is a particularly vicious species of dragon that feeds only at night.

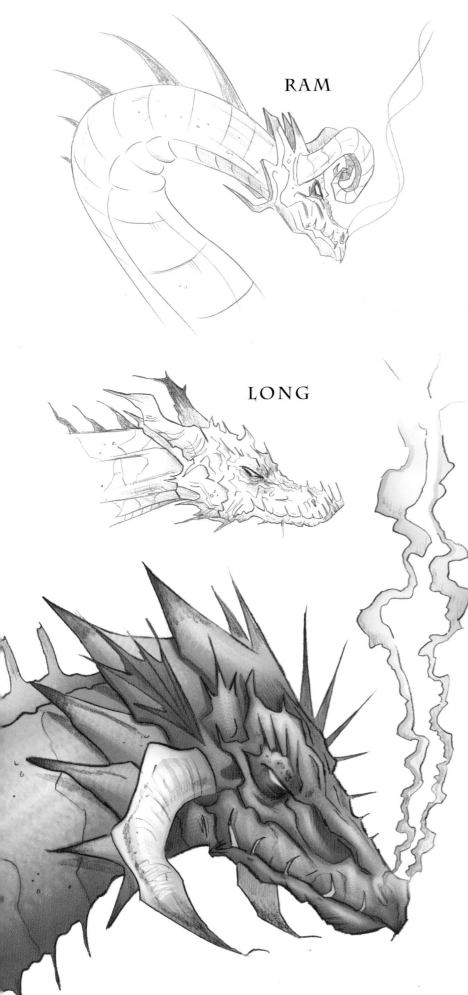

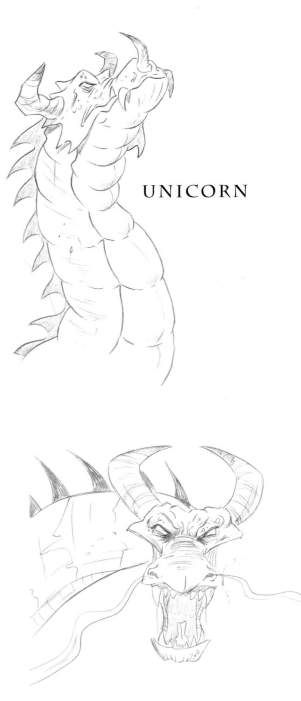

RAM

UNICORN

LONG

UPTURNED

UNDER-HORNS

Not included on the facing page, the under-horn dragon feasts on the unprotected eggs of other dragons.

THAT KEEN SENSE
OF SMELL

Dragons have exceptional nighttime vision and poor daytime vision. You may be hoping that this poor daytime vision is the chink in the dragon's armor. Oh, would that it were so. Unfortunately, the dragon compensates for this shortcoming with a sense of smell that's unparalleled in the kingdom of dark beasts. So finely tuned is this attribute that a mild breeze passing by a potential meal seven miles upriver, for example, will awaken a sleeping dragon. Therefore, hiding out of sight is of little practical use. But one can always hope.

WHAT'S A DRAGON WITHOUT FIRE?

If there is one talent that everyone associates with—and expects from—dragons, it's the ability to breathe fire. But the dragon is no mere "fire brute." He is a weaver of fire, an artist of flame. He manipulates the scorched air with the dexterity of an athlete, or like an expert fisherman casting his net into the sea—except that this beast casts his net for slightly more ambitious prey: humans.

THE MECHANICS OF BREATHING FIRE

The dragon's throat doesn't get burned from the fire it breathes because the fire originates as *fluid* and only ignites in the mouth, not in the belly. The fire liquid is secreted by a gland just above the intestines. It travels up to the back of the mouth, where it mixes with a substance secreted by an auxiliary gland located at the back of the roof of the mouth. A single drop of this second liquid is all that's needed to lay waste to an entire village.

Auxiliary gland

Main gland

Stomachs

Intestines

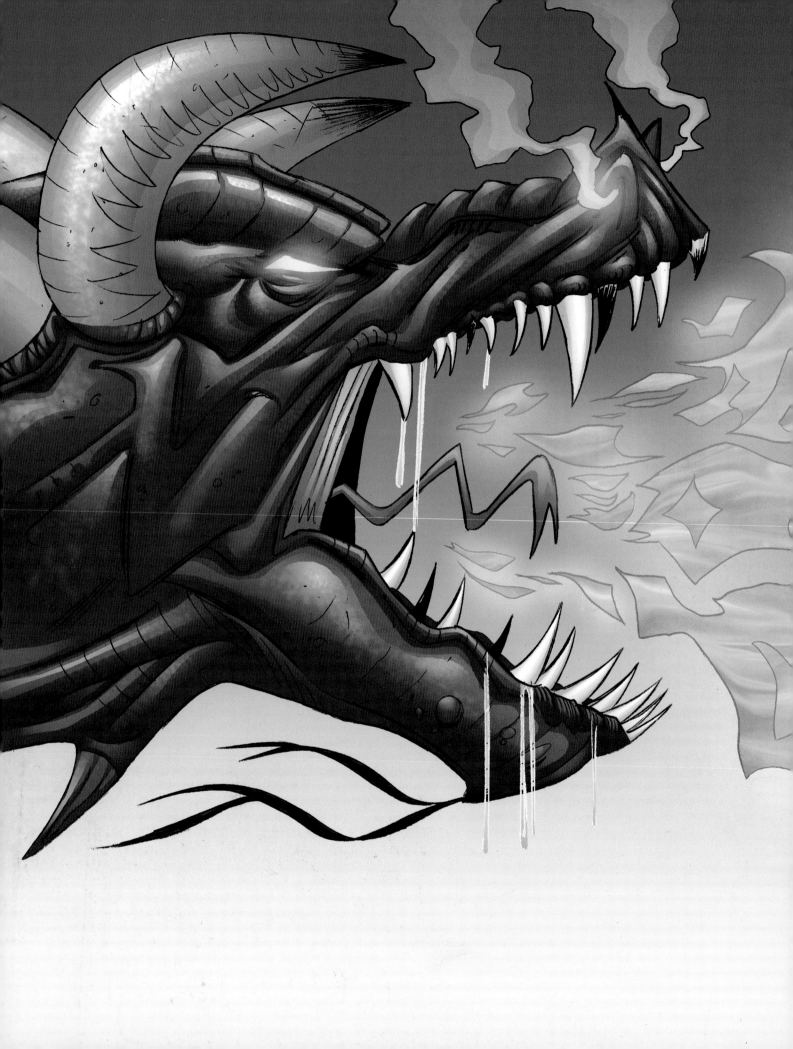

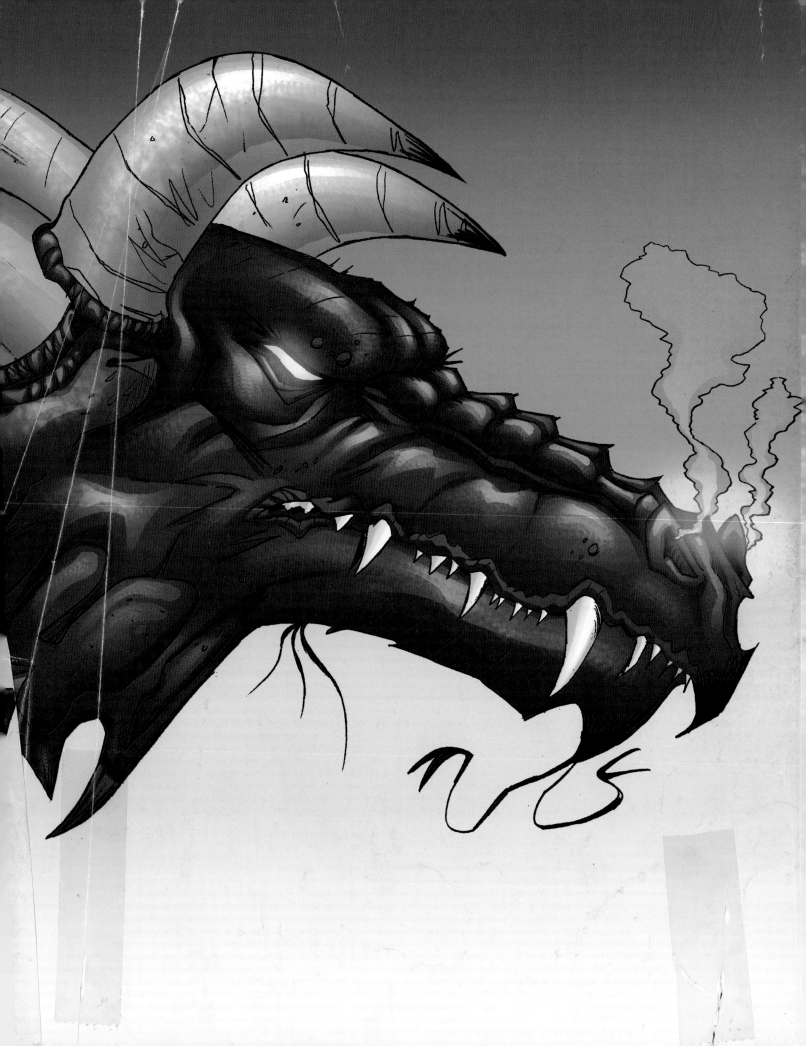

STREAMS VS. BURSTS

When a dragon is angered and intends to cause widespread destruction in its immediate area, it strikes out with a continuous stream of flame. However, when it is following a moving object, such as a knight on horseback, it will shoot bursts of flames in order to conserve the precious fluid—as it only takes one burst to kill its target. Conserving its liquid is vitally important.

BURSTS

STREAMS

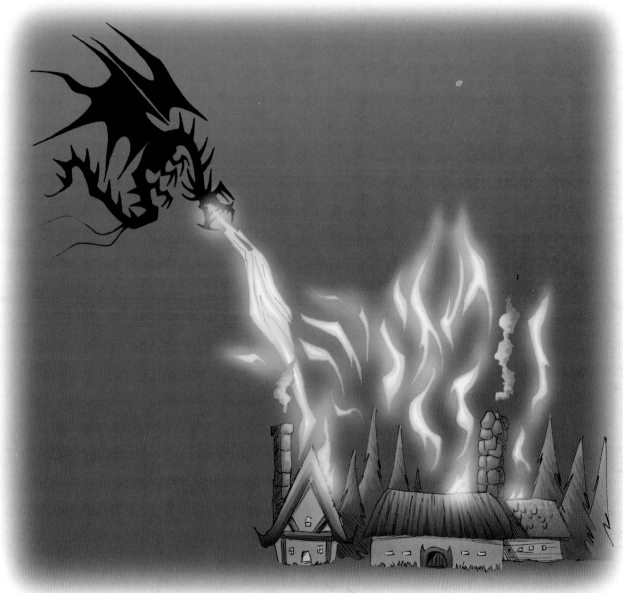

CONTROLLING THE FLAME

We'll get to the effects that fire-breathing has on the dragon body in the next chapter, but I just want to address how a dragon controls its fire. A dragon is like a master craftsman. It controls the band of flame as if it were a whip in its hand (or claw, as it were). By swiftly swinging its head in one direction and then back in another, it can shape and direct the strands of fire. It can literally entwine a castle in ropes of fire, burning it down in an instant. Dragons like to whip fire about. It's the equivalent of other animals knocking horns together in a show of strength or to establish dominance. It keeps their fire-breathing reflexes sharp. The more loops and curls it can make with the fire stream—and the longer it can make the streams—the more control it has of its weapon. Male dragons also use this skill to impress females during courtship.

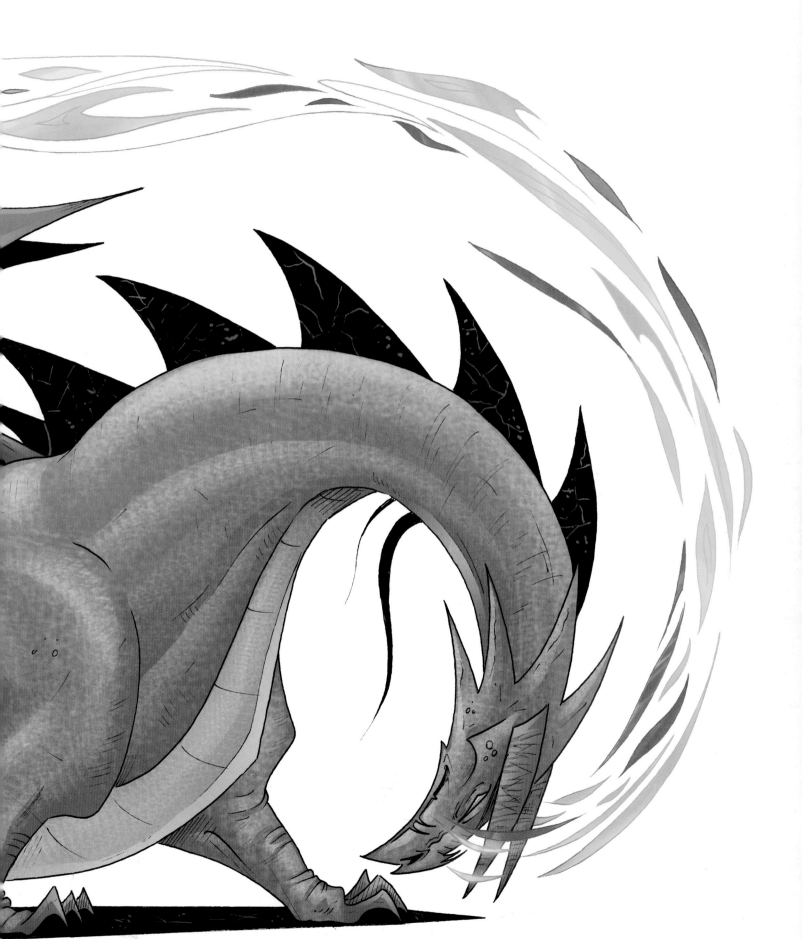

II

THE DRAGON BODY

T he dragon is a classical beast, a perfect example of brute force combined with grace and elegance. On the ground, its body is massive and clumsy, but its neck and tail have a balletic precision. In flight, its entire body cuts through the air with the synchronicity of an Olympic swimmer.

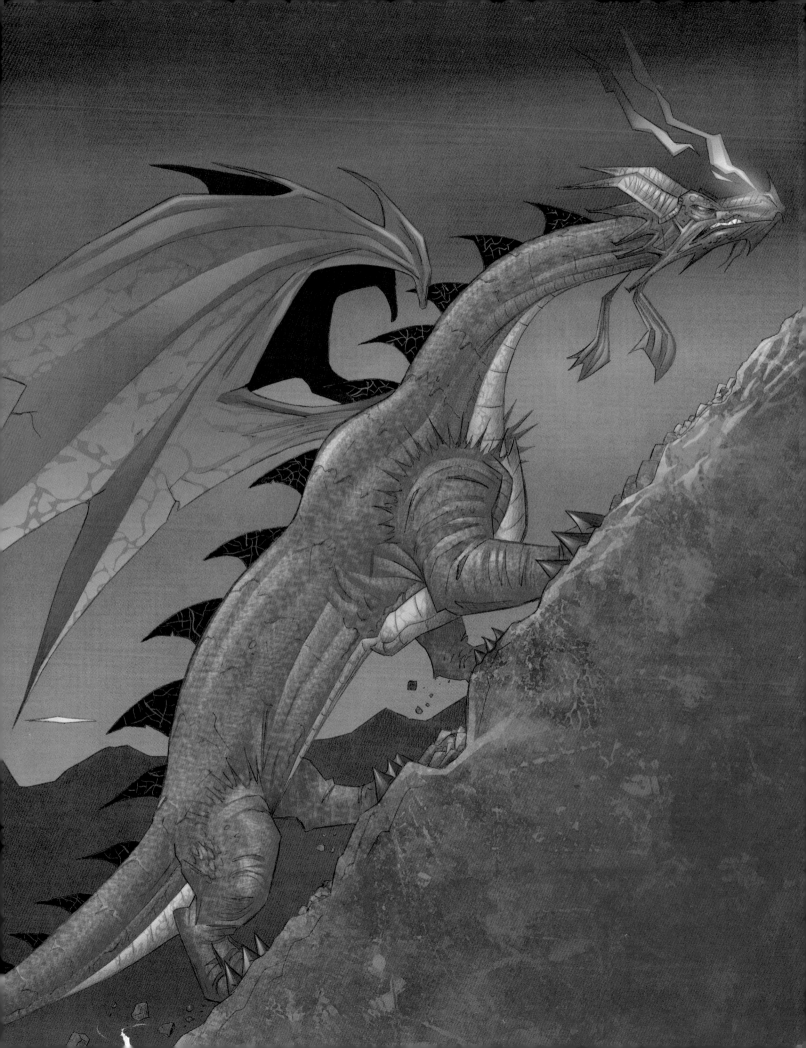

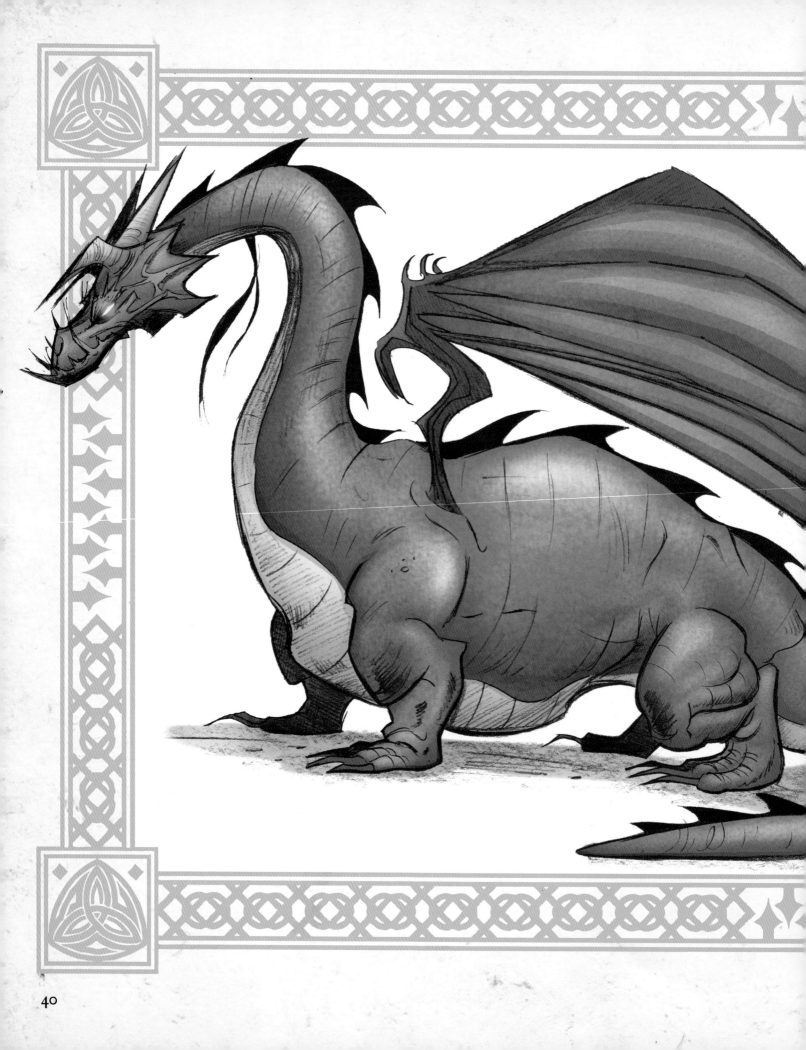

THE WONDERS OF THE DRAGON BODY

The dragon's chest is huge and powerful, as are the shoulders, yet the waist is small and athletic. The tail acts not only as a ballast for flying, but as a weapon, too. The legs are thickly muscled—they have to be because dragons weigh up to 12,000 pounds. But without a doubt, the most amazing muscle group of the dragon is the one in the neck. The neck is highly dexterous, quick-moving, and precise in that motion. Like the body of a snake, the dragon's neck can fully extend (when the dragon swallows its prey, for example) and recoil to its original position in less than .073 seconds. That's less time than it takes the human eye to blink.

BASIC ANATOMY

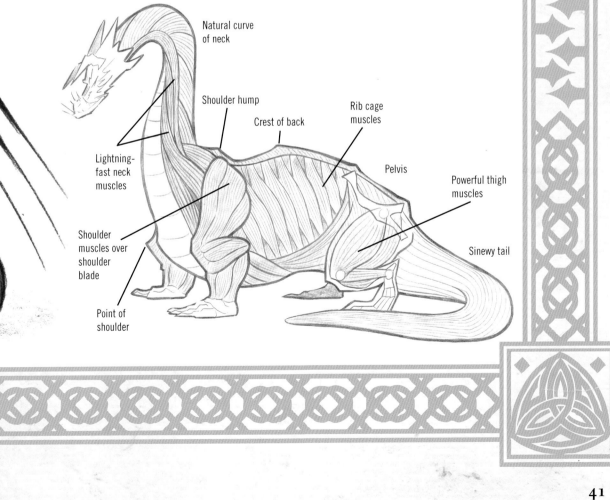

Natural curve of neck

Shoulder hump

Crest of back

Rib cage muscles

Pelvis

Powerful thigh muscles

Lightning-fast neck muscles

Shoulder muscles over shoulder blade

Point of shoulder

Sinewy tail

SIMPLIFIED SKELETONS

The dragon has a long spine. In any pose, the spine displays no sudden or abrupt change in direction. It curves fluidly. This is what gives the beast its awesome gracefulness. The rib cage is gigantic, with no bony structure at all between it and the pelvis—save for the spine—which is why the waist becomes so narrow.

Although many people new to the study of dragons assume that these fantastic beasts are directly related to lizards, the relationship is tenuous, for as you can see, dragon limb configuration is closer to that of mammals (such as dogs and bovines). The tail, feet, neck, dorsal spines or back plates, and head, however, are distinctly reptilian. The dragon is difficult to categorize, which is why it remains singular in its ability to fascinate.

On humans, the shoulder blades appear on our backs. On dragons, as with most four-legged creatures, the shoulder blades appear on the sides of the rib cage. And note that the vertebrae become much taller above the shoulder blades. This creates the pronounced hump at the base of the neck. The collar is the protrusion at the base of the neck. It's believed to be the vestigial rim of a shell, from a time when dragons could withdraw their heads into protective armor. But the fossil evidence for that is still somewhat sketchy.

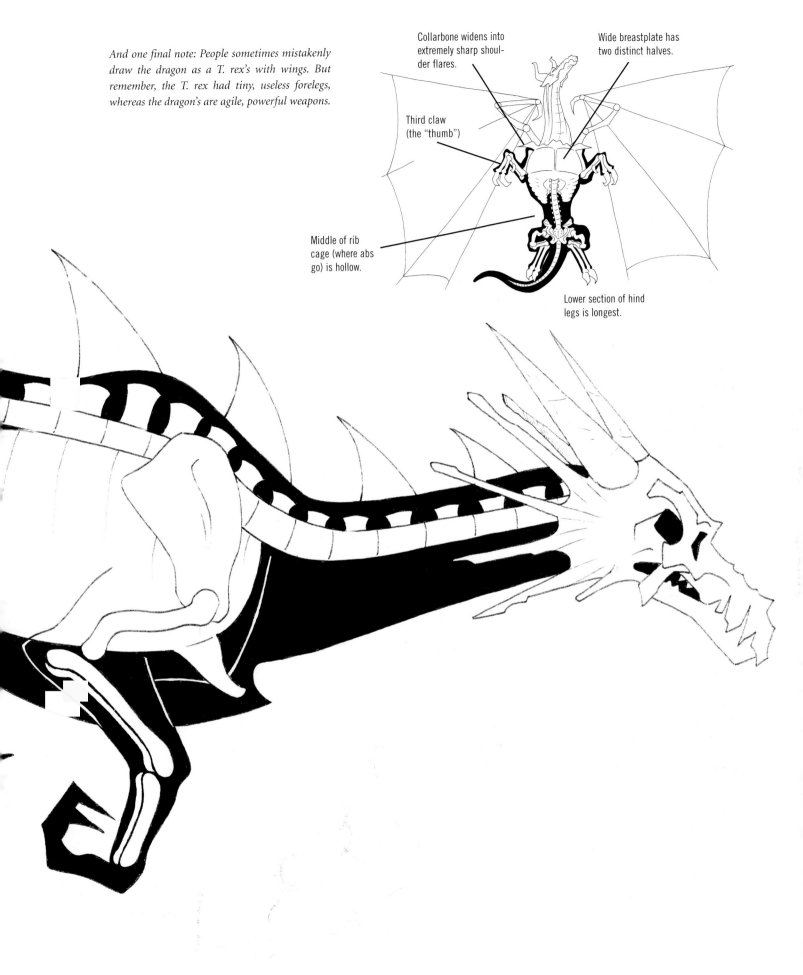

And one final note: People sometimes mistakenly draw the dragon as a T. rex's with wings. But remember, the T. rex had tiny, useless forelegs, whereas the dragon's are agile, powerful weapons.

Collarbone widens into extremely sharp shoulder flares.

Wide breastplate has two distinct halves.

Third claw (the "thumb")

Middle of rib cage (where abs go) is hollow.

Lower section of hind legs is longest.

DORSAL SPINES

The dorsal spines are the triangular plates that run the length of dragon's back. Beginning at the base of the neck, they become widest at the back, tapering off—and ultimately disappearing—by the end of the tail. There are many plate styles from which to choose. It's common for beginners to draw the dorsal spines as simple triangles, sort of like a series of pyramids along the back. This isn't so effective. To give the dorsal spines a feeling of movement, *tilt* them—draw them so that they all lean backward, toward the tail. See how this gives them a windswept look? Although there are many variations (and you can certainly invent your own), here are the four most popular:

CLASSIC

This is the most common type of dorsal spine. Note the cracks in the skin, which is extremely hard and dry. (See page 48 for more on dragon skin.)

ATTACHED

These spines are seamlessly joined to one another at the base. They're also more flexible and less rigid than the classic plates.

SPINY

Extremely thin and razor sharp, these can pierce the flesh like the quills of a porcupine.

IRREGULAR

Irregular spines have a two-tiered look, with a small point jutting out about midway up the back edge.

HOW THE DRAGON
USES ITS TAIL

There are three ways that a dragon uses its tail as a weapon: to swat at something, as a whip; to grab something like a boa constrictor; and the final way: When a dragon picks up unfortunate villagers with its tail, instead of suffocating them, the dragon wallops them up and down on the ground half a dozen times in rapid succession, as if it were holding a mallet.

A NOTE ABOUT DRAWING THE TAIL IN ACTION

When the tail picks something up, it wraps completely around the person or item a few times. It must also appear slinky and curved; this applies both to the part of the tail that actually grips the item and to the parts before and after that point.

CLAWS

The dragon's arsenal is multifarious and lethally effective. Blowing fire may take center stage, but it also takes a lot of energy, whereas a single swipe of the claw can instantly shred a dozen soldiers. Dragon claws, like human hands and feet, often assume graceful poses; the many joints make such movement and flexibility possible.

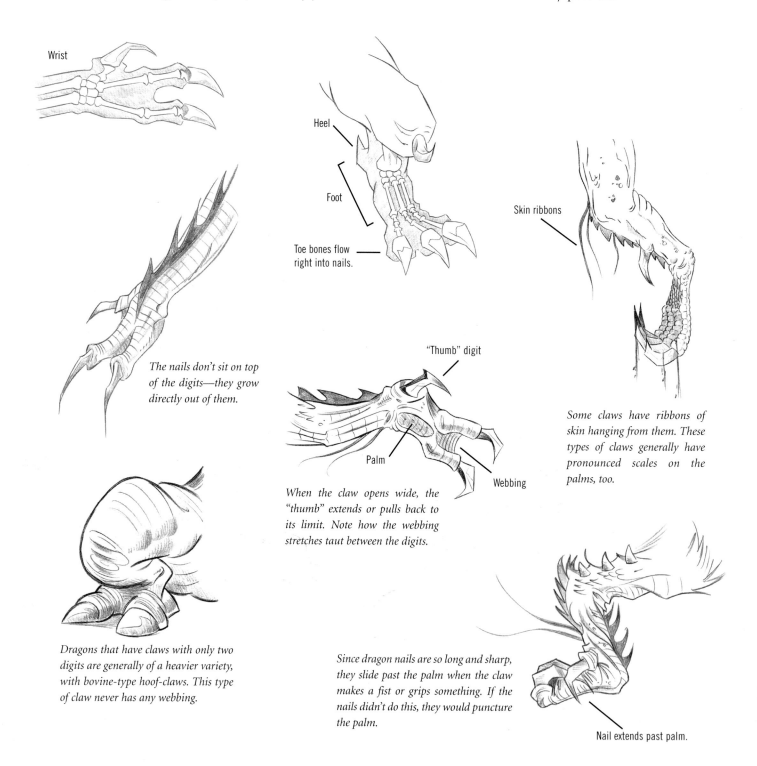

Wrist

Heel

Foot

Toe bones flow right into nails.

Skin ribbons

The nails don't sit on top of the digits—they grow directly out of them.

"Thumb" digit

Palm

Webbing

Some claws have ribbons of skin hanging from them. These types of claws generally have pronounced scales on the palms, too.

When the claw opens wide, the "thumb" extends or pulls back to its limit. Note how the webbing stretches taut between the digits.

Dragons that have claws with only two digits are generally of a heavier variety, with bovine-type hoof-claws. This type of claw never has any webbing.

Since dragon nails are so long and sharp, they slide past the palm when the claw makes a fist or grips something. If the nails didn't do this, they would puncture the palm.

Nail extends past palm.

THE CAGE OF DEATH

If you listen very closely on a moonless night, you can hear a low scratching sound that doesn't end until sunrise. It's the dragons, endlessly sharpening their claws against the walls of their limestone caves. It's a ritual, ever reminding the villagers that danger looms just beyond the horizon. The dragon is a living, breathing weapon. Any part of its body can be adapted for attack. Something as seemingly innocuous as a claw can be instantly transformed into a cage of death, a holding cell for its prey. Then, a call from the mother dragon to its young brings the hungry little ones scurrying over.

DRAGON SURFACE TEXTURES AND DETAILS

You may get the foundation of your drawing in place. You may have all the proportions right. But unless you add a convincing amount of surface texture, your beast won't come alive on the page as an earth-crushing, fire-breathing menace. What do I mean by *surface texture*? The craggy, weathered-looking skin, scales, warts, spikes, ridges, wrinkles, underbelly striations and more. These details appear all over the dragon, from the tip of its nose to the tip of its tail. They are the things that make a dragon look more like a lizard than a mammal, that give it that wonderful yet horrifying ugliness—that look that sends an electrifying chill down the spine of every human.

Many artists enjoy this part of the drawing process the most. Illustrators use the informal term *noodling* to describe it. It comes after most of the hard work of drawing the pose is done, and you can concentrate on the little details. It's the reward.

CRACKED & TORN PLATES

SPIKY GROWTHS

STRETCHED MUSCLE BANDS

UNDERBELLY RIDGES & STRIATIONS

48

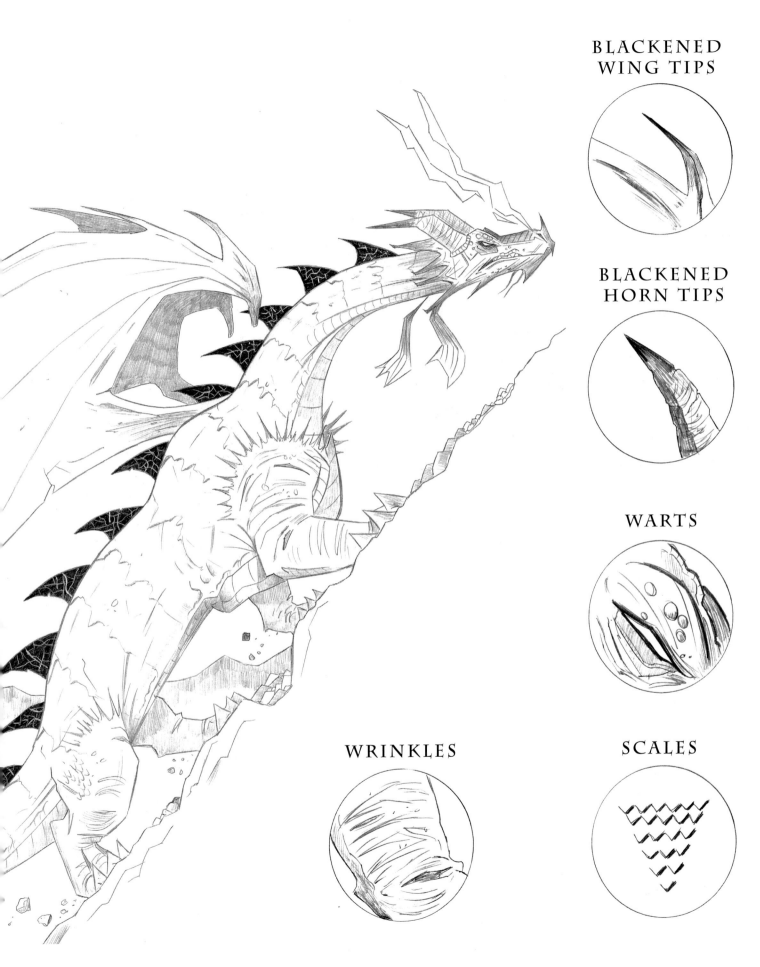

BLACKENED
WING TIPS

BLACKENED
HORN TIPS

WARTS

WRINKLES

SCALES

49

WINGS

The wing is like a human arm that's bent at the elbow, with the hand cocked so that it's facing palm out and parallel to the floor. The illustrations below show you how to make use of that comparison in your mind as you draw wings.

VERSION 1

In this version, there is webbing between the main branch and the first spine of the wing.

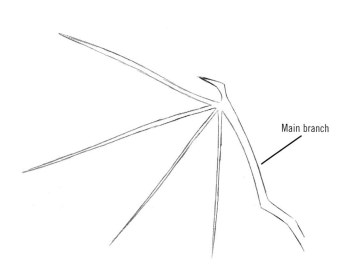

Elongate the spines even more, and spread them apart.

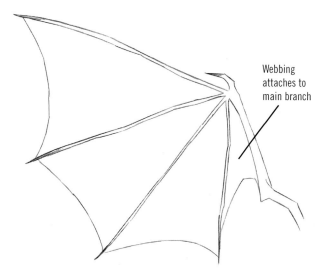

Main branch

Webbing attaches to main branch

When the spine length is right, add skin (webbing) between them. The skin should dip as it travels from spine to spine. Also add some texture to make what was formerly an arm look like bone and some tears in the wing, from wear.

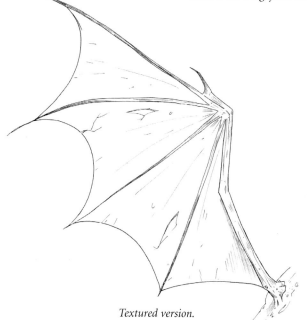

Textured version.

VERSION 2

In this wing type, the skin does not attach to the main branch. This gives the creature more of a gothic look.

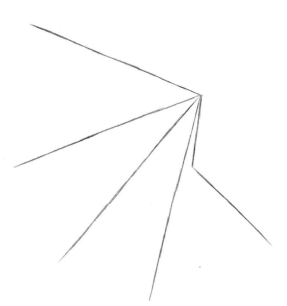

Start by drawing the spines at full length.

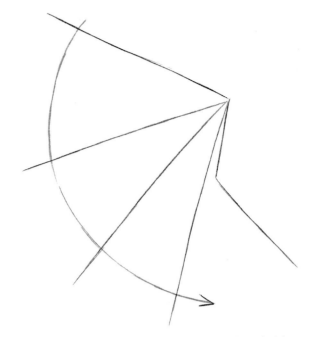

Sketch in an arced guideline a little bit before the end of the spines to show where the skin will attach to them. This guideline should cross each spine and should be sketched lightly because you will erase it in your final drawing.

Now add the actual lines indicating the skin. These lines should dip between the spines.

To finish, erase the curved guideline and thicken the bony framework of the wing, which doesn't attach to the main spine or "arm." And add the "thumb," hooking inward toward the spines.

WING JOINTS

The number of wing joints depends on the wing style. The wings here have three (not counting the point of attachment to the body). On the "power stroke," the wings reach down below the body, fully extended. However, in the "glide," when the wings lift above the body, as seen here, the joints reveal themselves. Dragon wings double back in a slightly contracted formation. This structure enables the dragon to gather power as it prepares to once again extend its wings downward on the power stroke.

In addition, collapsible wing structure enables the dragon to fly into small openings in its mountainside cave dwelling. It also makes it possible for the dragon to pull its wings in close to its body for warmth during long periods of hibernation.

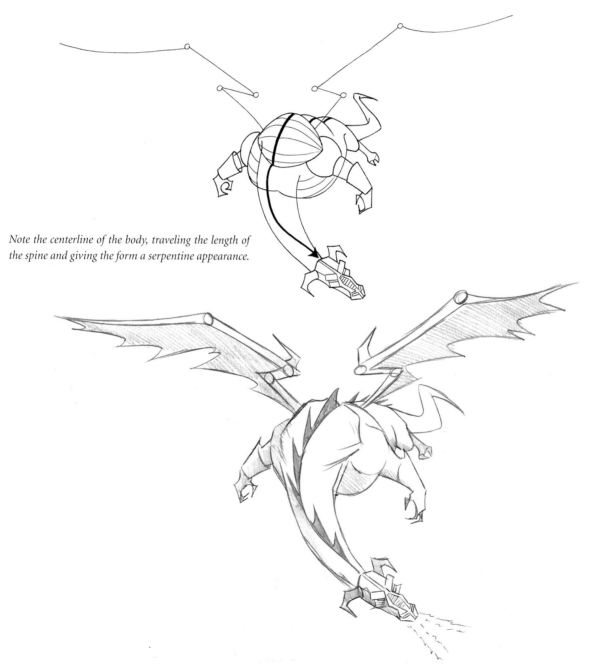

Note the centerline of the body, traveling the length of the spine and giving the form a serpentine appearance.

FLIGHT FORMATION

For the people in the Age of Fire, the ability to distinguish between dragon flight formations was essential for survival. Villagers had only moments to decide whether to abandon their homes and flee to the sanctuary of the forest.

The horizontal formation was a certain sign that the dragons were on the hunt. Surveying the landscape, they would pan out wide so as not to miss any movement along the ground. The V formation was travel mode. In this position, the dragons were simply flying from one destination to another, without sighting prey. The single-file formation was attack mode. A sighting had taken place, and the leader descended for the kill, followed by all the other dragons in single file according to rank.

BREATHING FIRE
WHILE STANDING

We covered the mechanics of producing and aiming fire in the last chapter. Now we'll see how fire-breathing relates to—and affects—the dragon body. If a dragon rises off its forelegs and blows heat, you must have done something to really annoy it. Dragons only do that when they're furious. And it's never a good idea to annoy a dragon. Unfortunately for the victim, the standing position shown here, with the torso bent forward, is the perfect position, mechanically speaking, for releasing the maximum amount of fire. Note the slight contraction in the belly, coupled with the forward-leaning posture.

The hindquarters are lower to the ground than the chest and upper body. In order to sustain the great weight of the beast, the feet have to turn out at a 45-degree angle. Only lighter creatures built for speed are born with feet that point straight ahead.

BALANCE & COUNTERBALANCE

This pose is all about balance and counterbalance and can add a fresh, exciting element to your fantasy artwork. Take a look at the concept. The *fulcrum* is the spot on the dragon at which there's as much weight to the front of the form as there is to the back. It's not always located directly in the middle of the form. To maintain balance in a dragon, the fulcrum must fall toward the hindquarters—otherwise, the dragon would topple over forward.

To provide counterbalance to the larger, front-of-the-fulcrum portion of the dragon, the tail rises. This not only serves to keep the figure in perfect balance, but it also creates a pleasing line that travels from the neck down the spine to the tail.

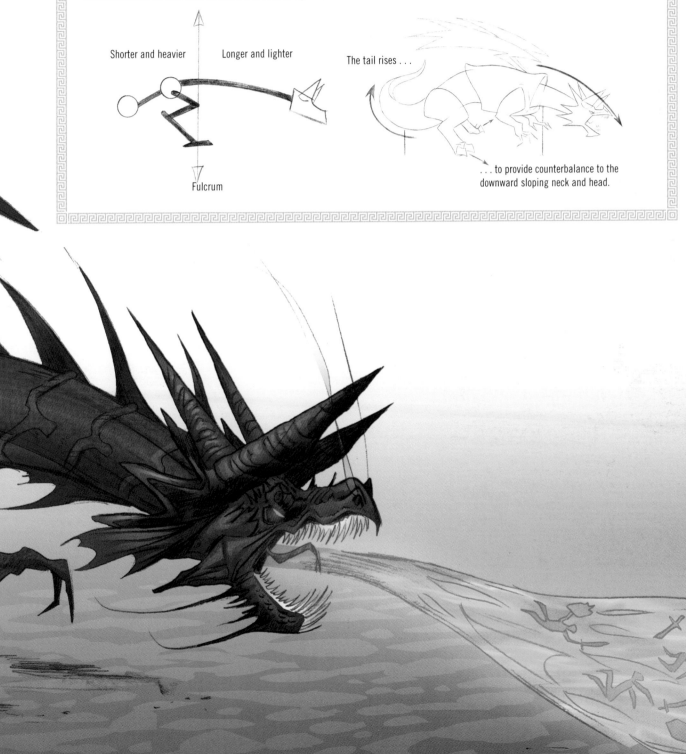

Shorter and heavier

Longer and lighter

Fulcrum

The tail rises . . .

. . . to provide counterbalance to the downward sloping neck and head.

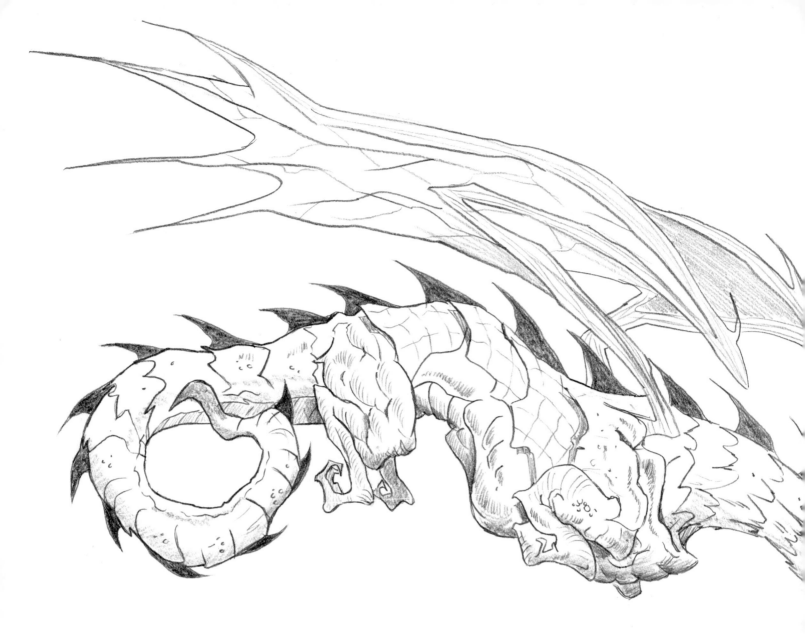

FIRE AND FLIGHT

The action of spraying a stream of fire exerts extreme force on the dragon's stomach muscles. Even in the middle of flight, the body has to go through a brief moment of severe contraction in order to flex the abdominal wall and spray the superheated flame.

FLIGHT SPEED

One note about the velocity of a dragon in flight: The straighter the spine, the faster the flight speed—but the less control the dragon has. The more curved the spine, the slower the speed and the greater the motion/fire control.

GREATER SPEED, LESS CONTROL

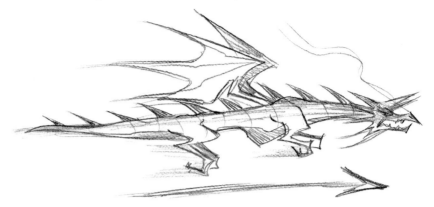

MODERATE SPEED, GREATER CONTROL

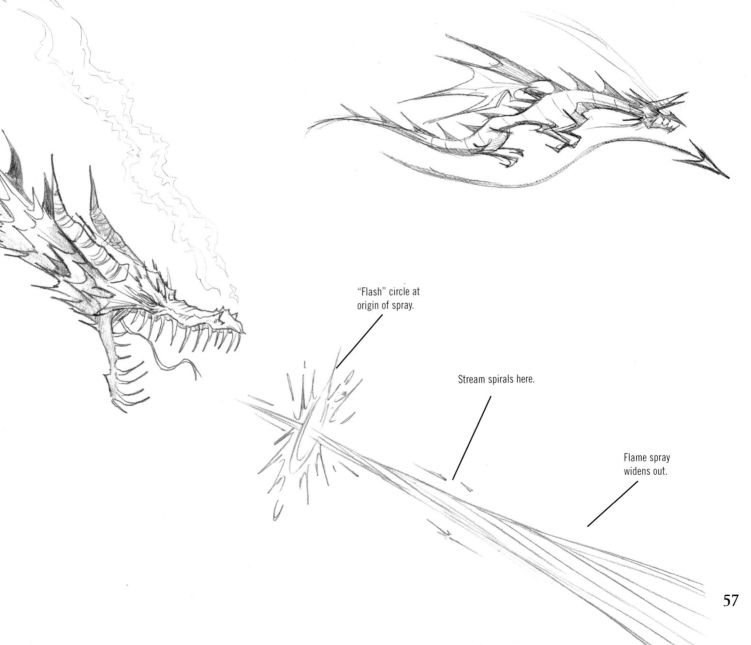

"Flash" circle at origin of spray.

Stream spirals here.

Flame spray widens out.

SKETCHING THE FORM

As you become familiar with the dragon body, it's a good idea to practice sketching it. Stay loose and draw quickly and boldly—that's the essence of sketching. And it brings a satisfying result. The line becomes intense. You can't get this look with a studied, carefully rendered line.

Not all images lend themselves to a sketchy treatment. But for those that do, the result is a unique sense of urgency and power—even when the subject is not moving.

Drawing like this is a valuable change of pace. It helps to build confidence, as well as *muscle memory*. This term, usually used in relation to athletics, refers to the training of a muscle so that the movement becomes automatic. For example, by swinging a bat over and over again in the proper manner, a baseball player no longer has to think about the mechanics of the action; he does it automatically. The same applies to the stroke of a pencil. With practice, the pencil stroke becomes engrained, which is why it appears to the casual onlooker as if the artist gets a drawing right on the first try. But actually, for the professional artist, that drawing is the five thousandth "try."

Note the reverse S curve that gives this pose its flow.

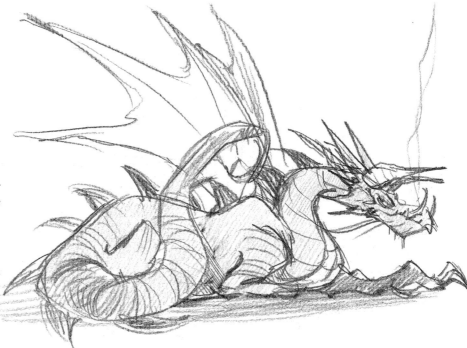

This pose shows the use of another S curve, this time in the neck. The body is a compact, half-oval shape.

58

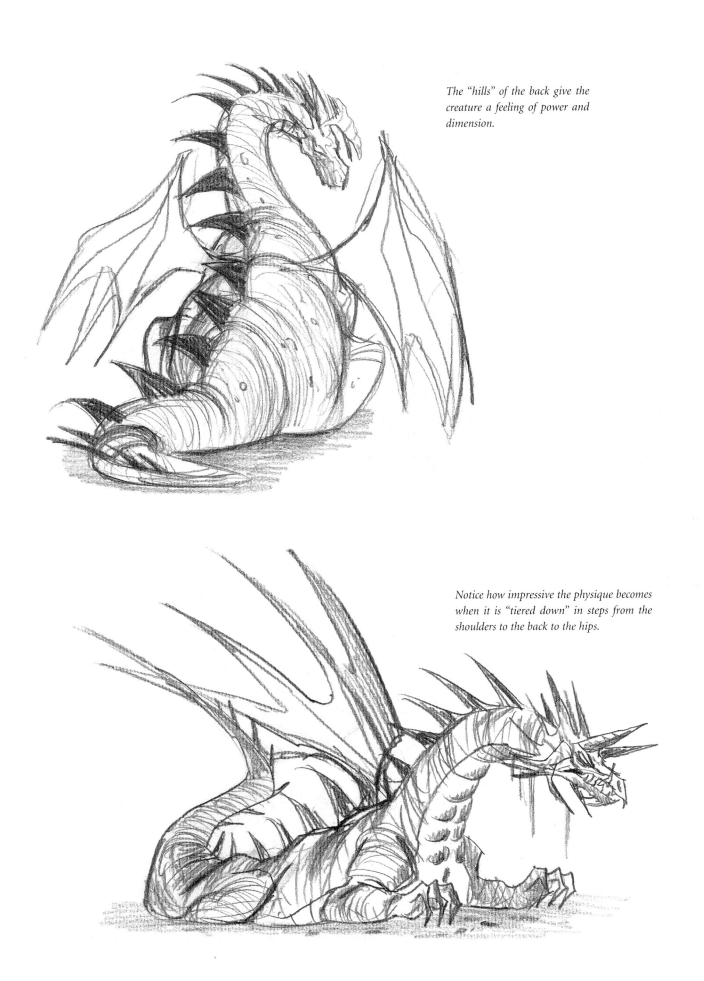

The "hills" of the back give the creature a feeling of power and dimension.

Notice how impressive the physique becomes when it is "tiered down" in steps from the shoulders to the back to the hips.

59

III

EXOTIC DRAGON SPECIES

Dragon is the genus, an animal group encompassing more than one related species. Many dragons evolved along separate lines, developing specialized strengths and skills. None of this is particularly good news for humans.

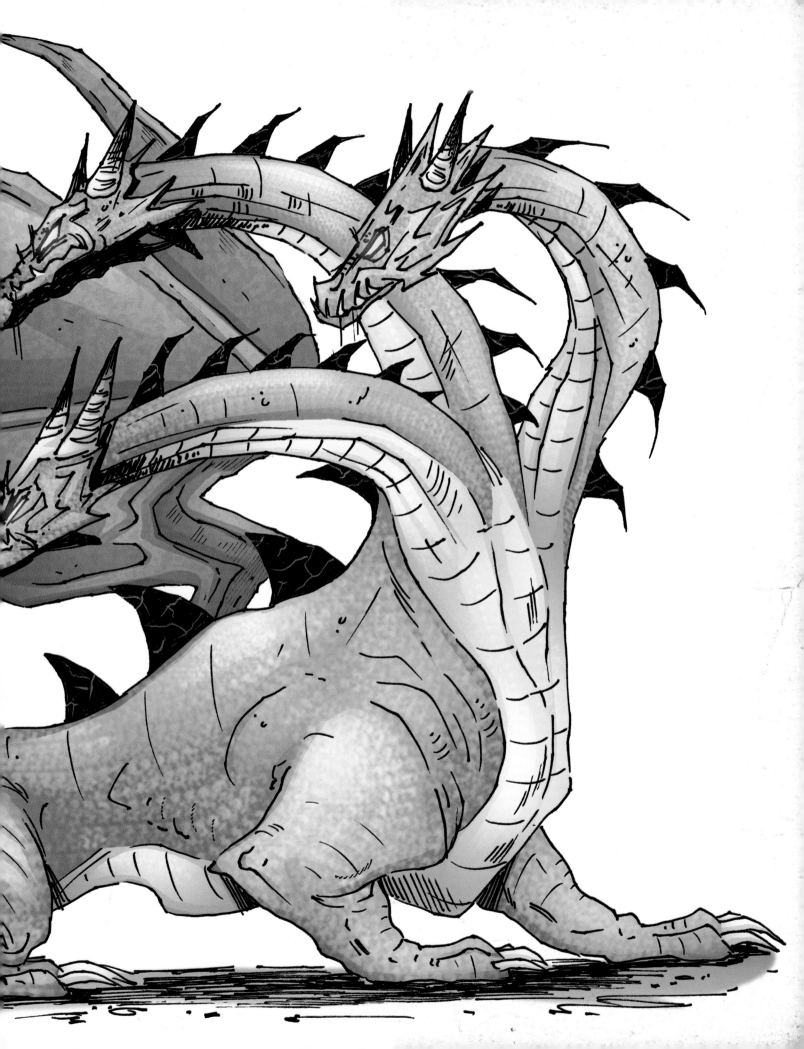

THE FLIER

The flier is the fighter pilot of dragons: nimble, quick, acrobatic, the predator of the sky. Its sleek body is tailored for flying. Before your very eyes, it can dive, snap up its victims, and fly away before they even have time to scream. Other dragons, being larger, might try to steal a free meal from the flier's mouth, but the flier is the only dragon that's also an adept swimmer. It will submerge—with its prey in its mouth—to ensure that no other dragons can steal its prize. Light and fast, this creature is vaguely reminiscent of the agile velociraptor dinosaur. The flier's one weakness: poor hearing due to its ear canal, which is extremely narrow to allow it to close when submerged.

When drawing a side view of a dragon in flight, draw a line of action, *which indicates the thrust of the body's motion and doubles as the spine. Make it flow smoothly, with gentle, sloping curves.*

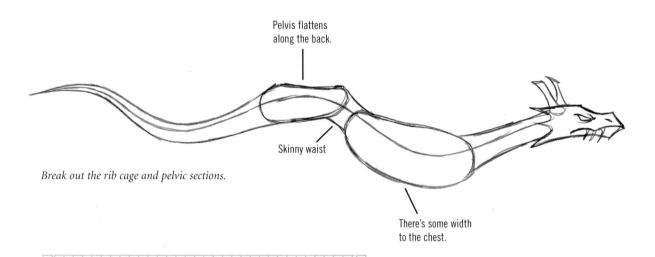

Pelvis flattens along the back.

Skinny waist

There's some width to the chest.

Break out the rib cage and pelvic sections.

THE RARE BREEDS
From an early age, humans had to learn the strengths and weaknesses of all dragon breeds— even the very rarest—in order to defend them- selves and their land.

62

Add some finishing touches. A series of jagged horizontal lines running down the length of the body makes this dragon look as if it is covered in hard plates. Small veins crisscrossing the wings make them look more realistic than if they were just big expanses of plain skin. The dorsal spines of varied heights add interest. Shading on the far wing, far legs, far horn, and underbelly adds depth to the form.

Far wing is shaded.

Far horn is also shaded.

As on all four-legged animals, when a foreleg extends forward, the rear leg on the same side of the body extends backward, and when the foreleg extends back, the rear leg on the same side of the body extends forward. The legs should taper to fairly delicate-looking claws, because the flier dragon should look seem light.

Draw large wings that go well past the dragon's rump. Remember to draw the wing on the far side of the body, too, otherwise the drawing will look flat.

THE THORN DRAGON

The various dragon types don't all get along well with one another, and dragons are fierce competitors in a world with slim resources. So, although not as particularly talented a flyer or as agile on the ground as some, the thorn dragon has developed a remarkably good defense against other beasts: its thorns. This dragon prefers to fight at close range for obvious reasons. Female thorn dragons have only one baby dragon every two years—far fewer than any other dragon—yet the mortality rate of these young dragons is low because thorn dragons are quite painful to eat. Weaknesses: Slow to move, slow to take off when becoming airborne.

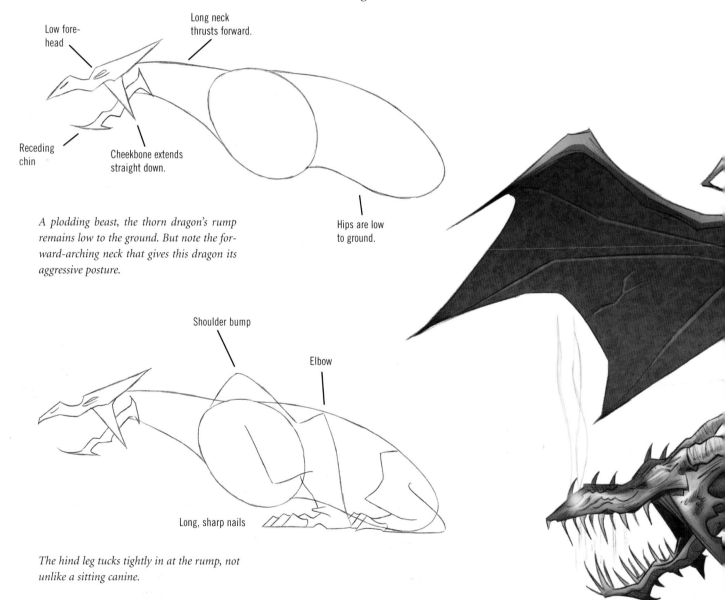

Low fore-head

Long neck thrusts forward.

Receding chin

Cheekbone extends straight down.

Hips are low to ground.

A plodding beast, the thorn dragon's rump remains low to the ground. But note the forward-arching neck that gives this dragon its aggressive posture.

Shoulder bump

Elbow

Long, sharp nails

The hind leg tucks tightly in at the rump, not unlike a sitting canine.

The thorns or spikes grow right out of the skin on all areas of the body. And you'll notice something anomalous about this particular species: It only has a few dorsal plates on its neck. It's one of the few dragon species that doesn't have dorsal plates running down the length of its back. That would interfere with the effectiveness of the thorns. Also note: In keeping with the prickly nature of this dragon, the wings are more jagged and pointy than wings on other dragon types.

Draw a line from the start of the neck to the shoulder to show the stretch. Also note the small but abrupt indent at the sternum (where the rib cage stops and the soft underbelly begins).

Complete the entire drawing before adding any spikes. When you look at the thorn dragon, the first thing you notice is the thorns, but that's because the body has been carefully structured and fully realized. This enables the reader to immediately believe the image. If your focus is backward—i.e., you concentrate on the thorns (the fun part) first and the structure of the dragon second—the eye will have to spend a few confused moments trying to figure out what the heck it's looking at. That's what every artists wants to avoid!

THE HYDRA

The hydra is a multiheaded drag-
on. Of all of the dragons in the
Dark Kingdom, the hydra is the
most formidable. With three snapping
heads attacking its target from different angles, distracting it
and relentlessly pursuing it, there's little chance of surviving
the encounter. It's like playing chess against three masters at
once. You can't afford to lose even one game. The hydra's one
weakness: If the middle head is cut off, the dragon will die. That's
why the hydra keeps continually weaving its heads back and
forth—to confuse its opponent.

POSITIONING THE HEADS

It may feel counterintuitive to draw all three heads of the hydra thrusting in the same general direction. After all, the advantage to having three heads would appear to be the ability to move them in three different directions at the same time. However, this is not the case. The real advantage is the ability to attack the same victim from three angles, making it impossible for the victim to mount an effective defense.

In addition, from a visual standpoint, you want to focus the intensity of the action, not dissipate it. When the three heads are dispersed in different directions, the moment is weakened. When all three heads come together, the drama is strengthened.

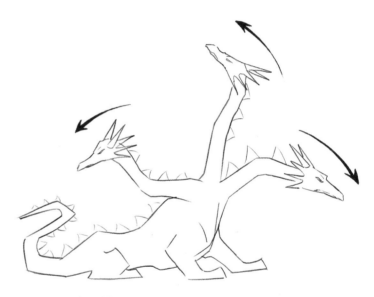

WEAK

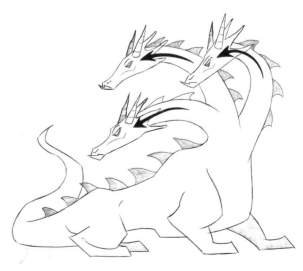

STRONG

THE COLOSSUS

This is the largest dragon that ever existed. Its sheer size enables it to trample anything that stands in its way. It's tremendous. It's so large that its belly literally drags along the ground at all times. Everything about it should look immense. For best results, draw this dragon with a person or some other object of a known size so that the true scale of the beast is easily grasped. In addition, when drawing any awesomely huge character, it's always a good idea to draw from a low perspective so that you seem to be looking up at it. Legend has it that only one colossus dragon is born every hundred years. The colossus weakness: The bigger they come . . .

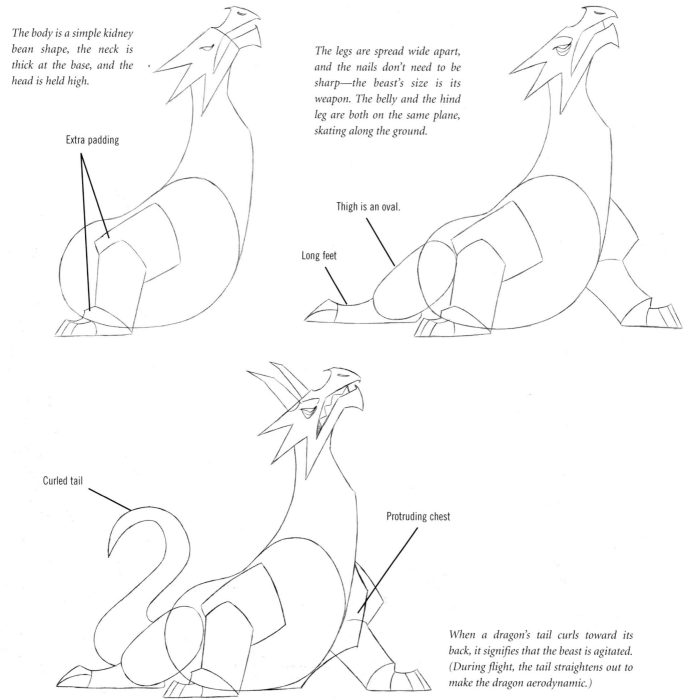

The body is a simple kidney bean shape, the neck is thick at the base, and the head is held high.

Extra padding

The legs are spread wide apart, and the nails don't need to be sharp—the beast's size is its weapon. The belly and the hind leg are both on the same plane, skating along the ground.

Thigh is an oval.

Long feet

Curled tail

Protruding chest

When a dragon's tail curls toward its back, it signifies that the beast is agitated. (During flight, the tail straightens out to make the dragon aerodynamic.)

DIDN'T YOUR MOTHER TELL YOU NOT TO PLAY WITH YOUR FOOD!

The colossus doesn't always kill its victims by breathing fire, stomping, or biting. It just tosses them into the air and lets go. It's important to draw the people near the dragon's mouth in silhouette only, so that they appear tiny. The moon is positioned behind the people to provide the rationale for the use of silhouettes: backlighting.

And notice this subtle but effective technique: The warrior on the ground is closer to us and, therefore, slightly larger. In addition, because of his larger size, you can add some lighting effects to his body so that the moonlight shines on his front while his back is darkened. The long shadows behind his feet give him an extra-lonely look.

IV

THE CYCLE
OF LIFE

Birth, mating, and death. It has been such for the beasts of the earth since the beginning of time. It begins in the cool caves at the foothills of the red river and ends in the dusty sand dunes under an unforgiving sun.

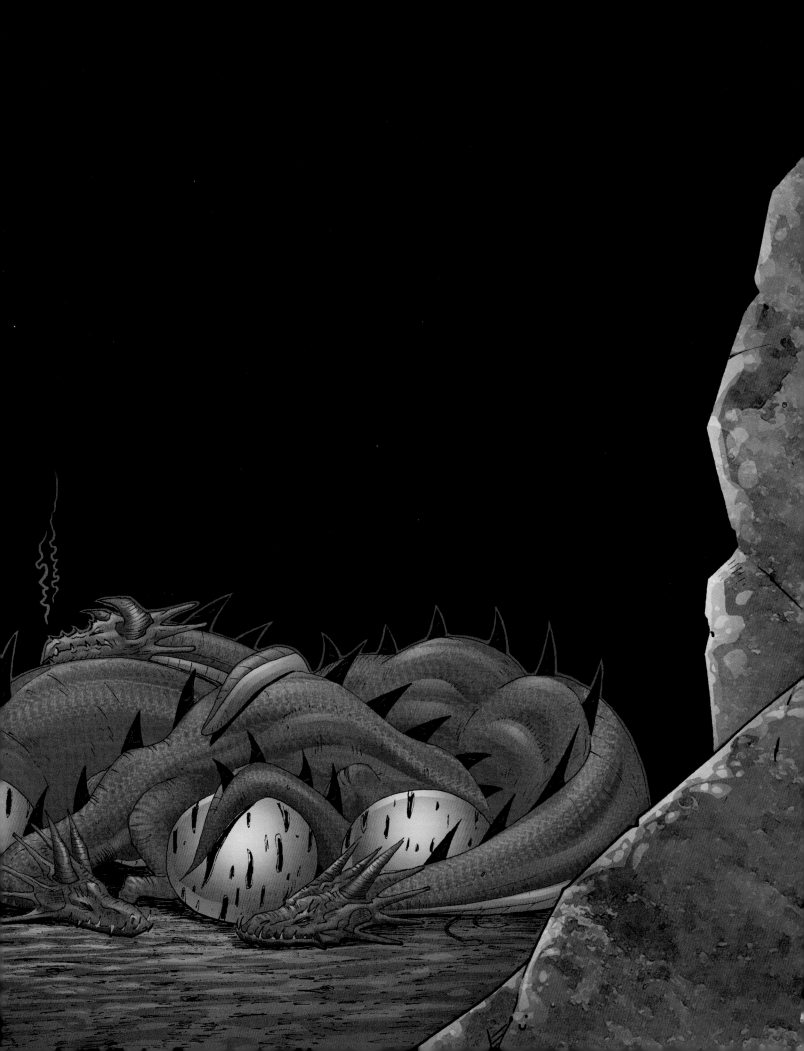

RETURNING TO BREED

Once every eleven years, dragons gathered to spawn. As the full moon cast its first haze upon the mountain, they would come. Dozens of them. Over hundreds of miles and from distant lands. Some would fly over water. Others would come from deserts and over rocky terrain. They bore the seeds of a new generation of dragons. They needed to replenish the flock.

Dragons would fly for days without food or water to get to their breeding grounds. Some died of exhaustion before they got there. A few were felled by archers' arrows, although most flew too high to fall prey to men. One by one, they would reach the summit, and men could only watch.

Spawning time was the dragons' only time of vulnerability as they refused to leave their eggs, growing weaker as their need for food continued to gnaw at their bellies. Incubation took up to seven months, providing villagers barely enough time to fortify their bulwarks—for dragon youngsters had to feed immediately after being born.

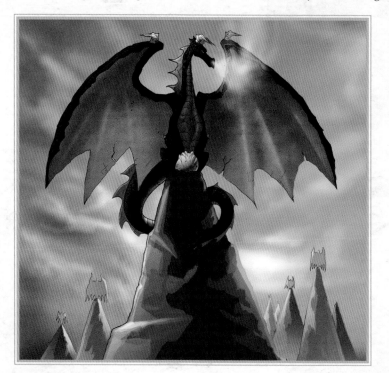

BIRTHING IN THE CATACOMBS

For safety reasons, only dragon queens birth alone in the catacombs. Out of jealousy, infertile females have been known to steal the babies of other dragons. This dragon is a queen. The size of her egg implies this. Here, she tucks her body into a tight ball for a long hibernation. Draw the bottom of her body flat, as if her great weight were compressing her body and pressing it into the ground.

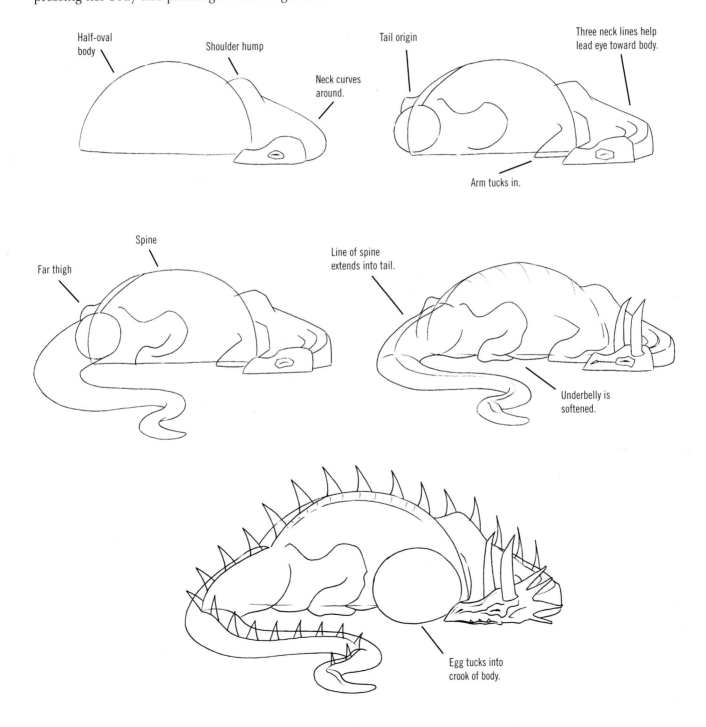

Half-oval body

Shoulder hump

Neck curves around.

Tail origin

Three neck lines help lead eye toward body.

Arm tucks in.

Spine

Far thigh

Line of spine extends into tail.

Underbelly is softened.

Egg tucks into crook of body.

THE GOOD MOTHER

Hard as it may be to believe, dragons—that vicious species that terrorized mankind for millennia—were nurturing, devoted mothers. They would sacrifice their food, sleep, even their very lives for their young. They even seemed capable of love. One could admire them. But should one therefore spare the life of a mother dragon? An orphaned baby dragon would surely perish without its mother. But, sparing the mother's life could possibly seal the fate of an entire village of people. The world posed—and still poses—great complexities to those with a conscience. Such is the human condition. What would you do?

A NOTE ABOUT DORSAL PLATES

When you draw dark dorsal plates against a light background, the plates read well. But, what happens when you have black dorsal spines appearing against a black backdrop, as in the image on page 71? In order to prevent the plates from disappearing into the dark background, simply draw a thin, white outline around each dorsal spine. The dorsal spines will then stand out, even though they are black on black.

It took several steps to arrive at this sketchy drawing. And that's a good lesson: What may appear to be a casual sketch is, in fact, a well-planned drawing. You don't have to draw extemporaneously to achieve a sketchy look. Just work out the basics in advance, and then trace over your drawing in a sketchy manner on a light box and/or on tracing paper. Having a well-thought-out drawing underneath as a guide gives you the freedom to work sketchily on your second draft.

BABY DRAGONS

Baby dragons had a surprisingly agreeable look. Some people even were tempted to care for them as pets. It never worked out well . . . at least for the humans.

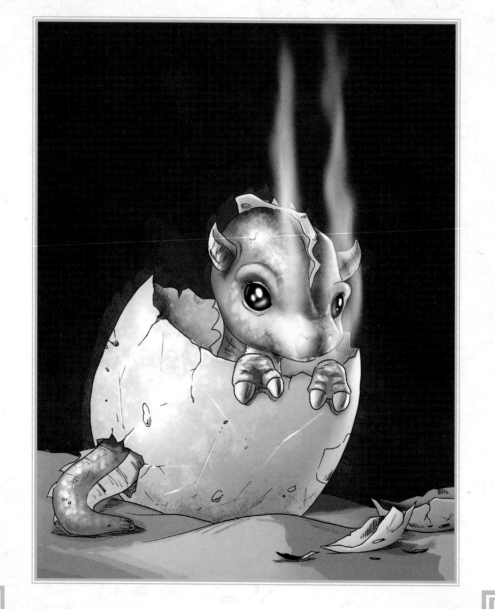

HOW MUCH IS THAT DRAGON IN THE WINDOW?

Oh, this is bad. Really bad. I've seen this happen before. She's been told by her parents to take that dragon out of the house, bring it back to the woods where she found it, and *leave it there*. But look at her. I'll bet my bottom dollar she doesn't do it. It's always the same plea: But mommy, I love him. He'll change. He's not like all the rest. (To this day daughters are still saying the same thing about all sorts of strange creatures.)

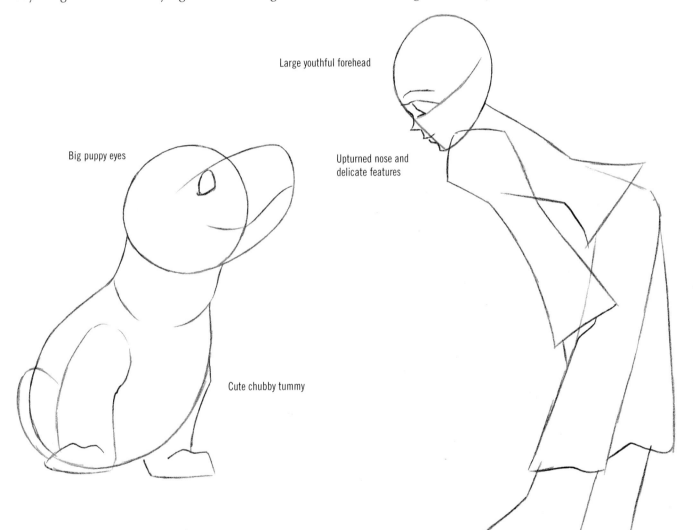

Large youthful forehead

Big puppy eyes

Upturned nose and delicate features

Cute chubby tummy

To create a sympathetic pose for a baby dragon, imitate the sitting position of a well-fed puppy dog. The girl is a young, elfin tween of the forest. So, make her limbs lanky and her joints flexible. Specifically, the elbow and knee joints should bend slightly backward (hyperextending) under pressure.

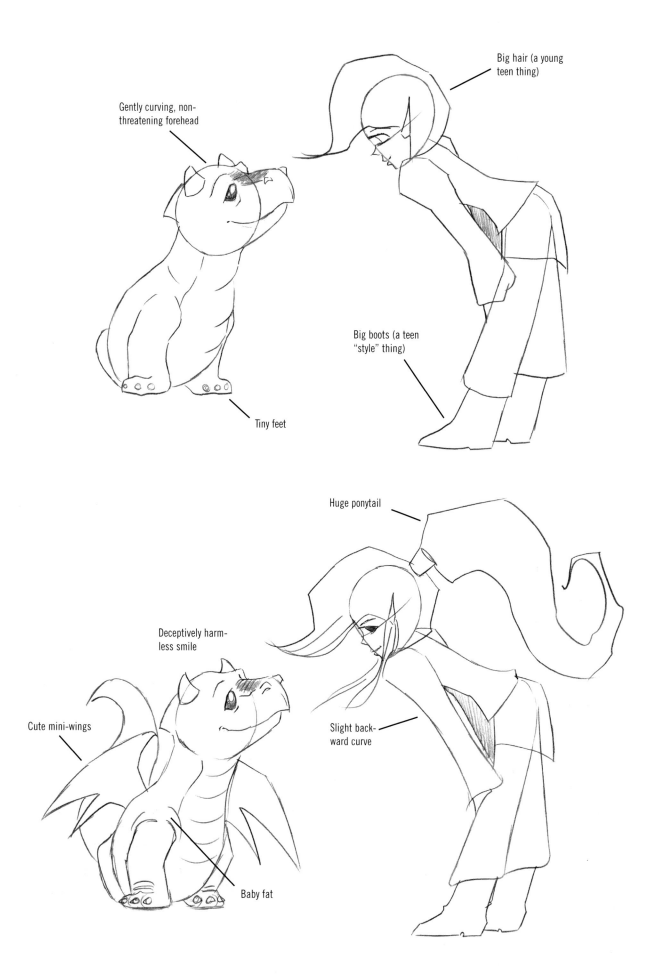

Gently curving, non-threatening forehead

Big hair (a young teen thing)

Tiny feet

Big boots (a teen "style" thing)

Cute mini-wings

Deceptively harmless smile

Huge ponytail

Slight backward curve

Baby fat

78

Look at both of them together. Maybe they really will be best friends . . . that is until the dragon's baby teeth fall out.

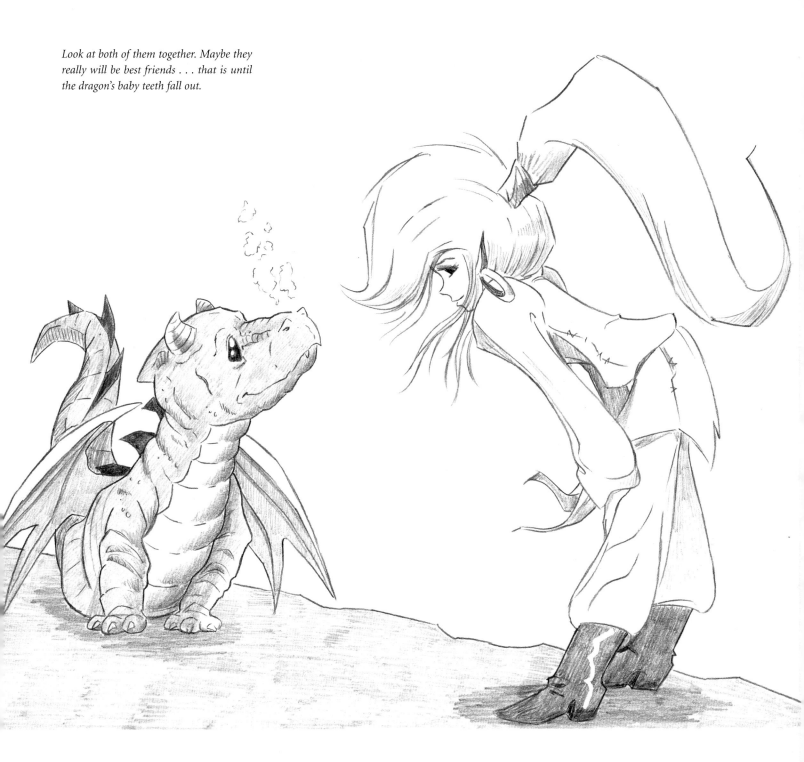

Dragons are notorious cave dwellers, preferring the darkness to the light. Many forest animals are attracted to caves as an excellent form of shelter from harsh weather. It's vitally important, however, that such animals select the correct cave.

THE DRAGON BURIAL GROUND

In an endless procession, one by one, the dragons came here to die. Death came for dragons of all species, shapes, and sizes. They dragged themselves, using every remaining ounce of strength they had, to take their last breaths among their brethren. The dragon burial ground was a harsh place, with piercing winds and pelting sandstorms. Nothing much remained there, save for a few horns, a skull, the mountains, and time.

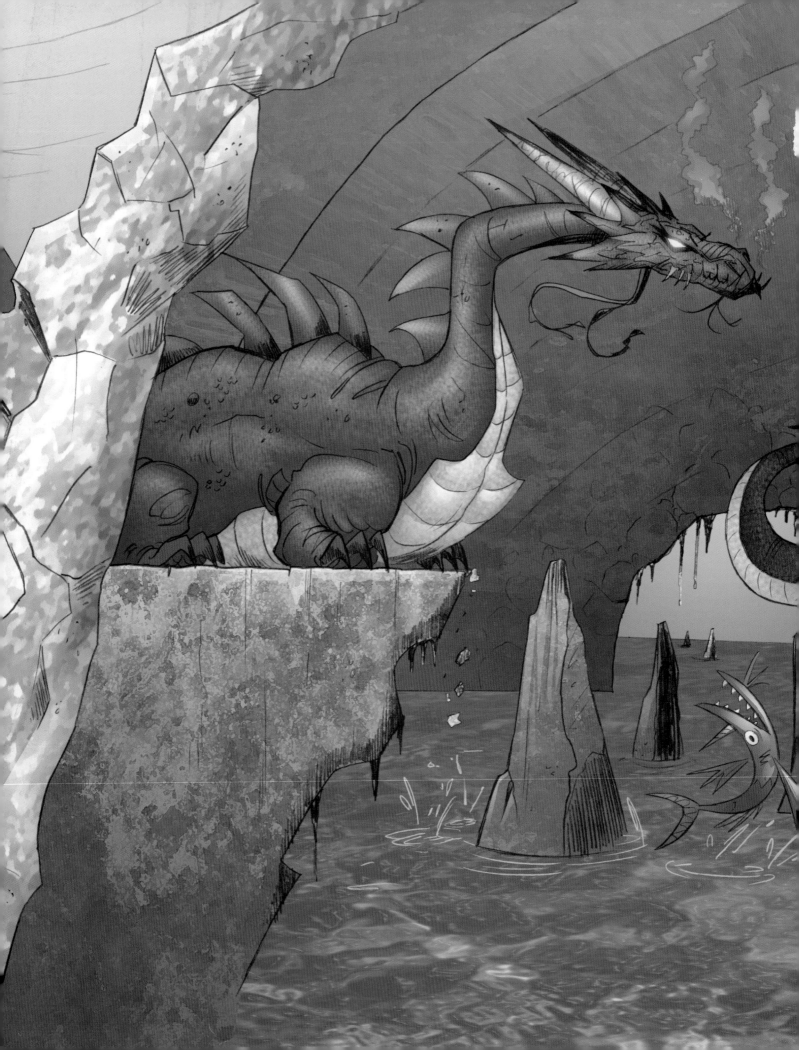

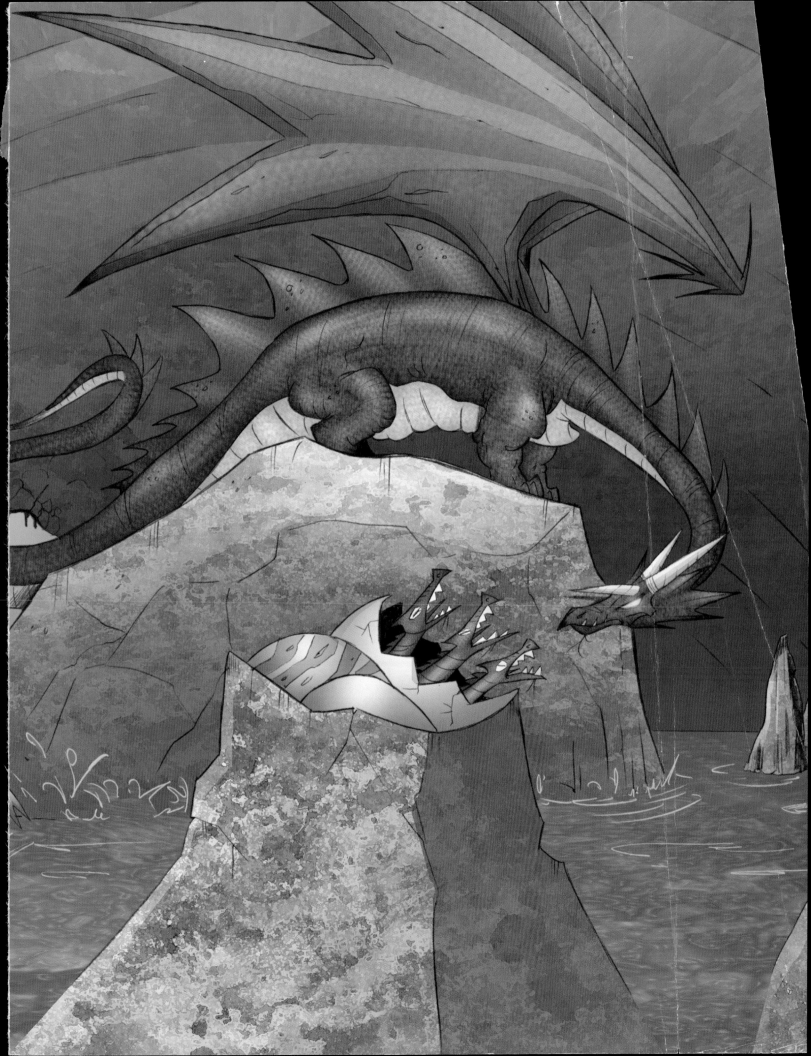

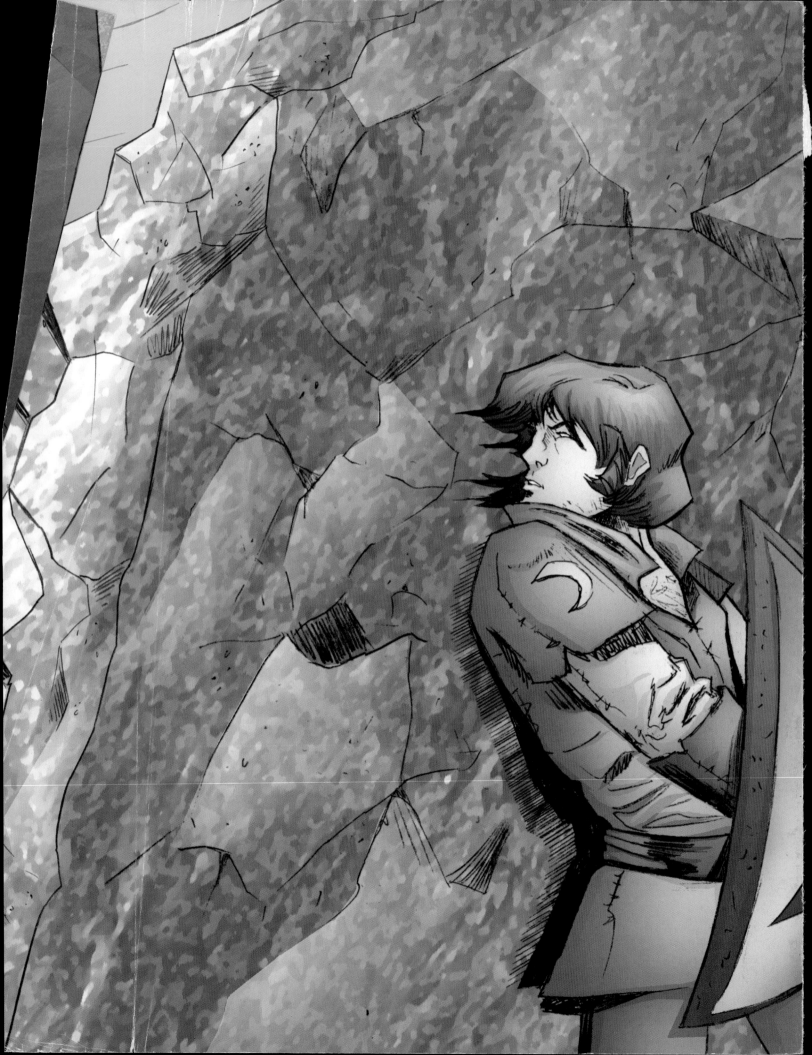

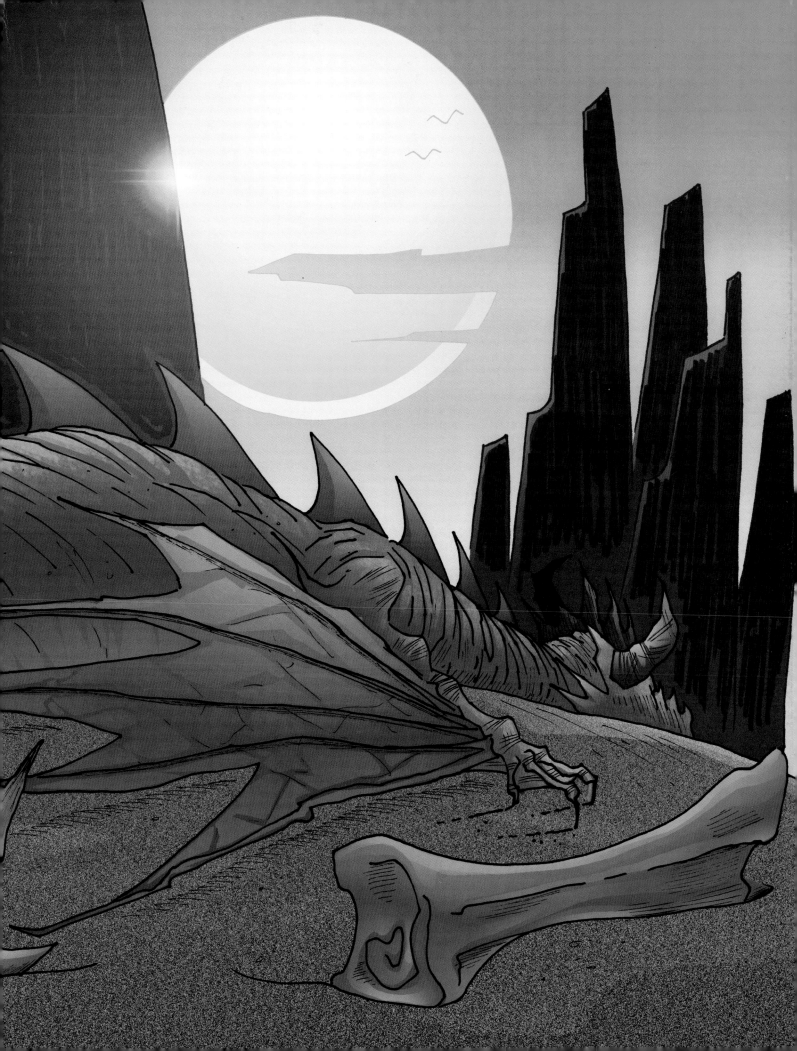

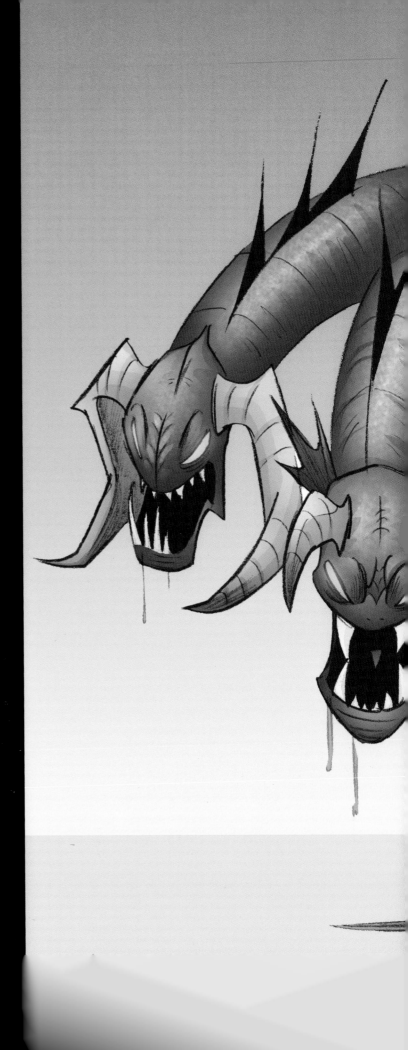

V

CREATURES OF THE DRAGON WORLD

The land of dragons was populated with strange, powerful creatures. To complete the dragon world in your art, you must know how to draw at least some of these imposing beasts.

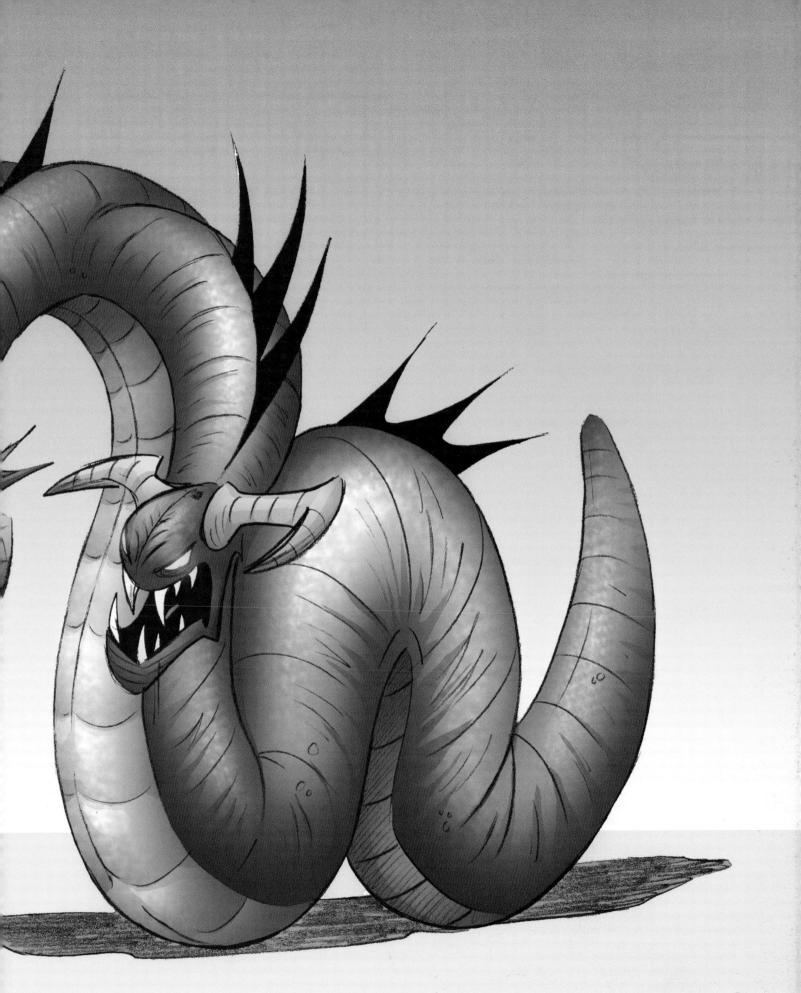

MEN IN A WORLD OF BEASTS

Men captured and domesticated many of the lumbering giants of the dragon world to plow their fields and build their bridges. Other, faster animals were used for riding. Some relayed urgent messages from one village to the next. While many creatures were simply too dangerous to attempt to control, some proved to be loyal companions that defended their masters from the fire-breathing scourge. Still, most were beasts of burden. Either way, they were indispensable for the survival of mankind in the era of fire. This meant that those who could train these huge creatures were valued workers, with a special place in society. They were often knights, recognizable by the long, upturned horns on the sides of their helmets. They had a more dramatic build than that of ordinary villagers and frequently wore garments with sharply flared shoulders.

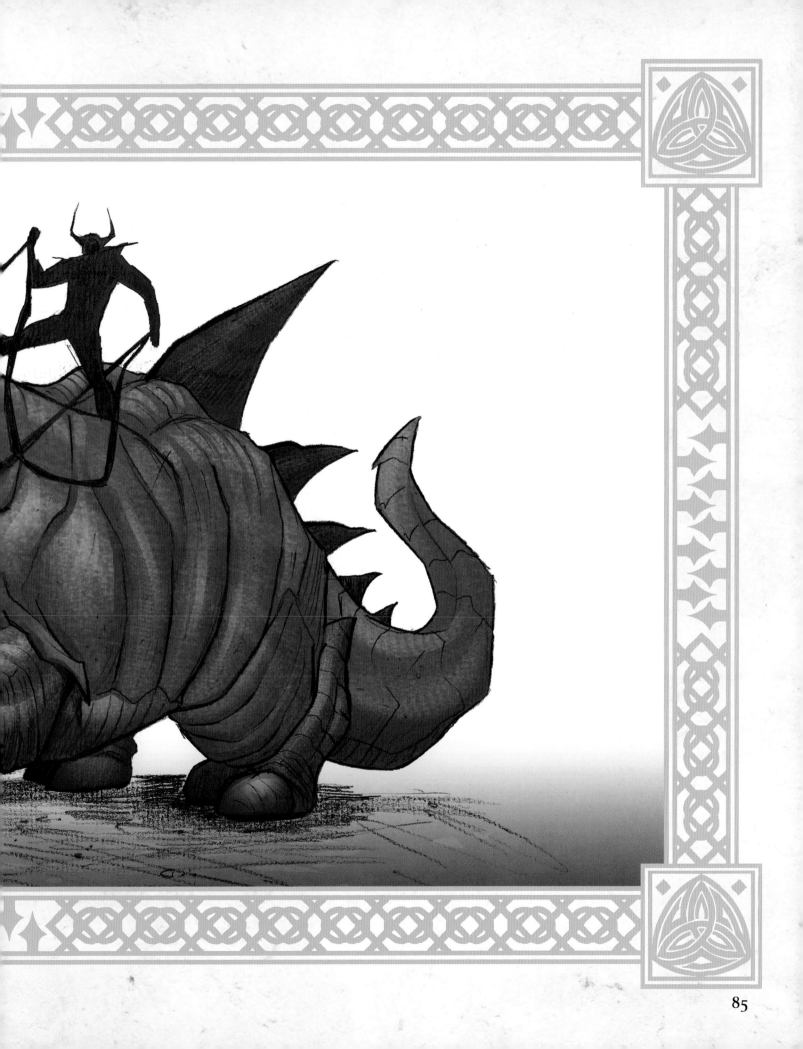

THE GIANT LIZARD

As a fantasy artist, your skill set is incompete unless you can draw the giant lizard. Don't let the textured skin and finishing touches fool you: The basic construction is straightforward and easy to achieve.

There are two basic lizards body types: lean and chubby. the lean type is personified by the iguana, and isn't so popular in the fantasy genre. The chubby type, however, is. think Komodo dragon, which is fuller in the belly than the iguana.

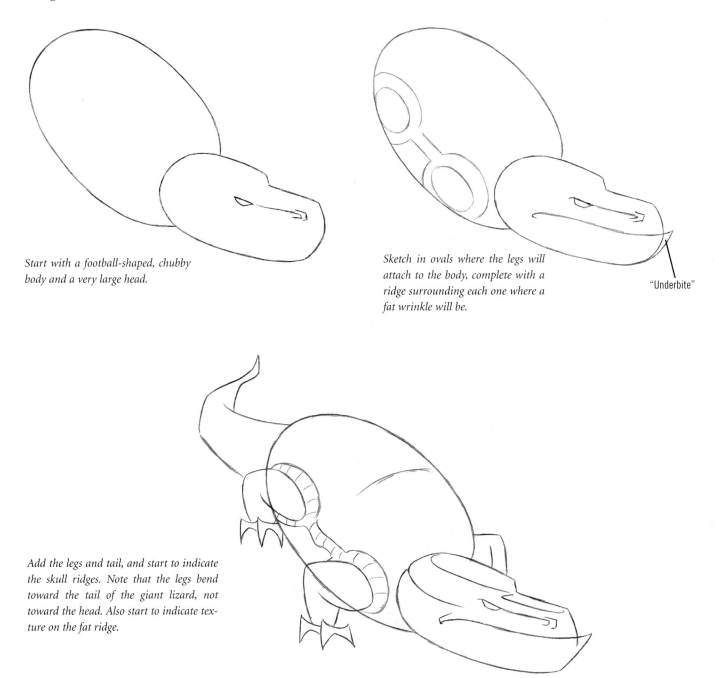

Start with a football-shaped, chubby body and a very large head.

Sketch in ovals where the legs will attach to the body, complete with a ridge surrounding each one where a fat wrinkle will be.

"Underbite"

Add the legs and tail, and start to indicate the skull ridges. Note that the legs bend toward the tail of the giant lizard, not toward the head. Also start to indicate texture on the fat ridge.

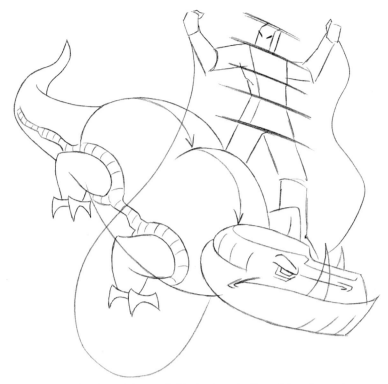

CONVEYING ENERGY WITH MINIMAL DETAIL

This lizard handler looks dynamic despite the fact that his form reveals very few details. How is this possible when we can't even see his face? It's because he's positioned at an angle to the picture plane, rather than in a flat, straightforward pose that's parallel to the picture plane. The angle conveys the energy.

Don't be afraid to omit details. Often, evil or soulless characters are drawn as faceless entities devoid of features—they have increased physical stature but no minds of their own. It's a good dramatic drawing technique.

To give the lizard a solid, rounded look, show the line of the spine on its back, and create a hill-and-valley effect with the spine dipping and rising. To correctly proportion the man's body, sketch some guidelines to indicate the major sections of the body (head, collarbone, upper chest, waist, bottom of hips), and then sketch in the form.

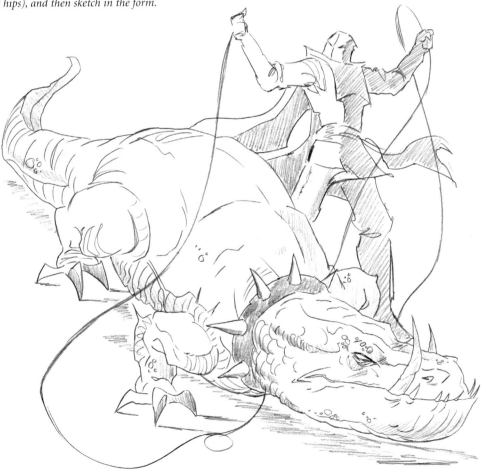

THE GIANT "BIRD"

This birdlike creature stands high off the ground on stiltlike legs. The head is reptilian, with sharp teeth, while the body is reminiscent of the emu, a flightless Australian bird. Like the emu, this creature is capable of running at a fast clip. It is an effective means of transportation but has a nasty personality, hence the strap around its mouth—so that it can't bite its owner!

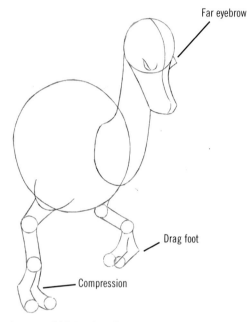

Far eyebrow

Drag foot

Compression

In a 3/4 pose, which is what this is, the bottom of the creature's neck extends past the outline of the body. To further get the position of things right, the center line (on the head) falls three-quarters of the way back on the form. Also note the use of circles to indicate the joints.

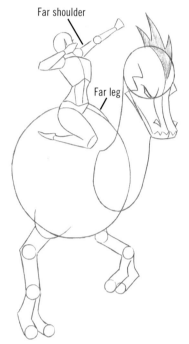

Far shoulder

Far leg

Animals walk with their heads down at a 45-degree angle—they don't hold their heads up like humans.

Note the long, sharp nails, similar to what you find on a raptor. It "bookends" the reptilian theme, which began at the creature's head. The woman's long, flowing hair gives her a presence without which she would be badly overshadowed by the creature.

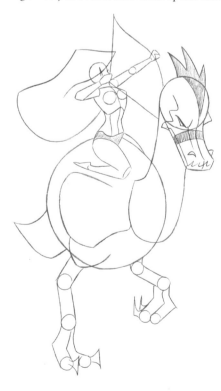

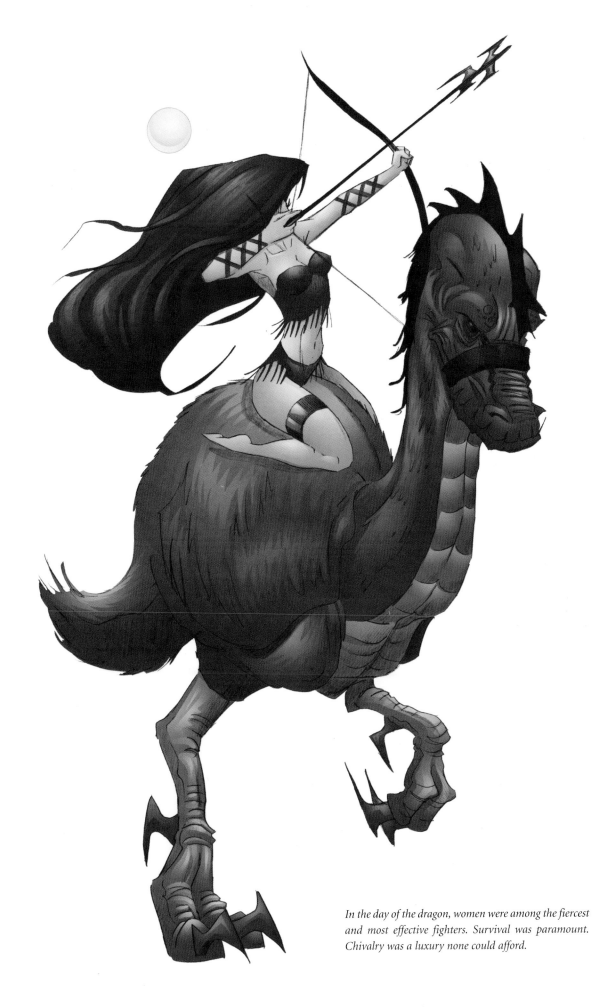

In the day of the dragon, women were among the fiercest and most effective fighters. Survival was paramount. Chivalry was a luxury none could afford.

THE THREE-HORNED TIGER

A crouching posture is an effective position for any large cat. In this pose, the back slopes in a sharp diagonal, and the rear legs bend deeply. The body should look as though it's moving backward, while the legs should look as if they're going forward. That's the key to a good crouching pose. While this is a fearful pose, for this aggressive hunter it works well with the bared teeth, raised foreleg, and extended claws ready to strike.

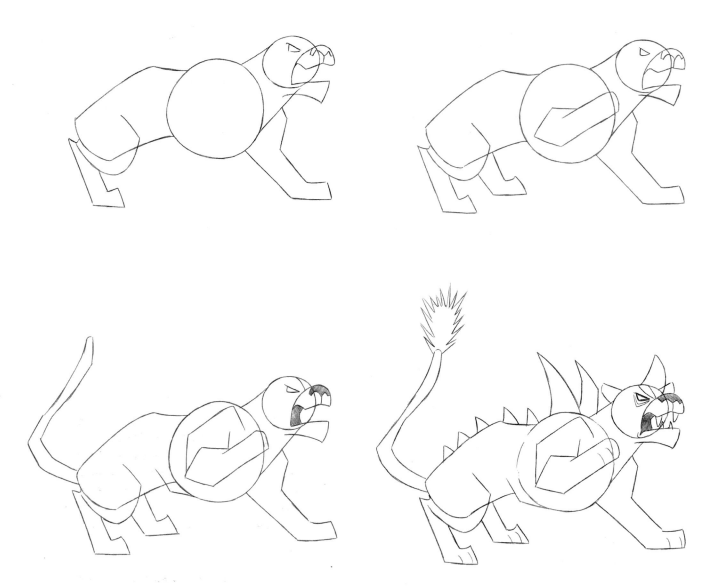

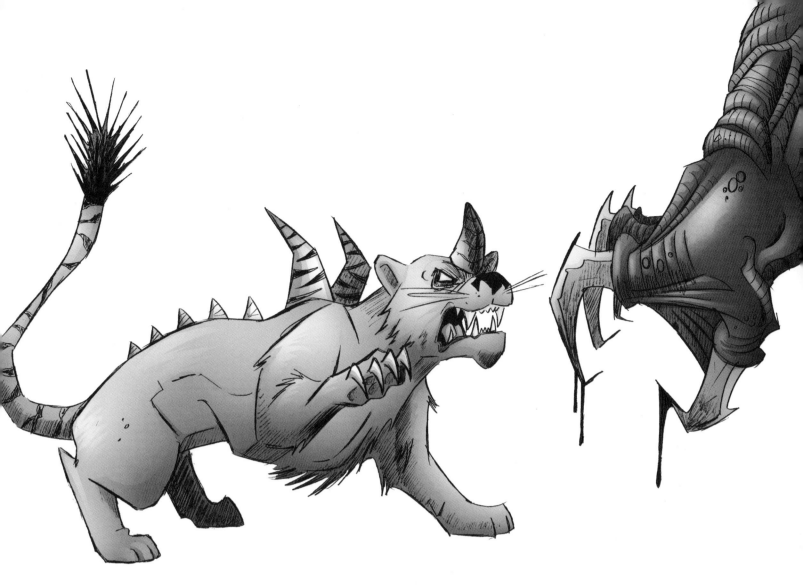

DERIVING FANTASY CREATURES FROM REAL SOURCES

Obviously, this creature is based on a large cat, such as a tiger, lioness, or panther. The key to creating fantasy creatures is to use actual animals for inspiration and add a few motifs that will transform them into something otherworldly—but not unrecognizable. Stay in keeping with the theme of the world you've set up. For example, feathered wings wouldn't work on the three-horned tiger. Feathered wings connote an angelic spirit. And who wants to see a tigerlike creature flying around, anyway? The dragon is the star flier of this world. We've established, however, that horns and dorsal spines are a theme of this land. So are spikes and thistles and things that make you go "ouch." In addition, the empty eye, without the pupil, underscores a demonic personality. Those details work well on this character in this fantasy world.

Character design is an exercise in trial and error. Be prepared to fill up the wastebasket with half a dozen attempts before hitting on what works. And remember this: Your imagination is like a buffet. Always consider a few different selections before deciding on what to go with!

HELLWORMS

These feared creatures emerge from holes in the ground with frightening speed, attack their victims, and then pull them down into the ground to their lairs to devour them. Once a hellworm pulls you below ground, there's absolutely no hope of being saved.

Draw all of the worm heads identically, but vary the shapes of the horns. By drawing the heads with the same, terrible expression, you create an almost mechanical killing-machine look, but the horns will add a subtle touch of variety to avoid monotony.

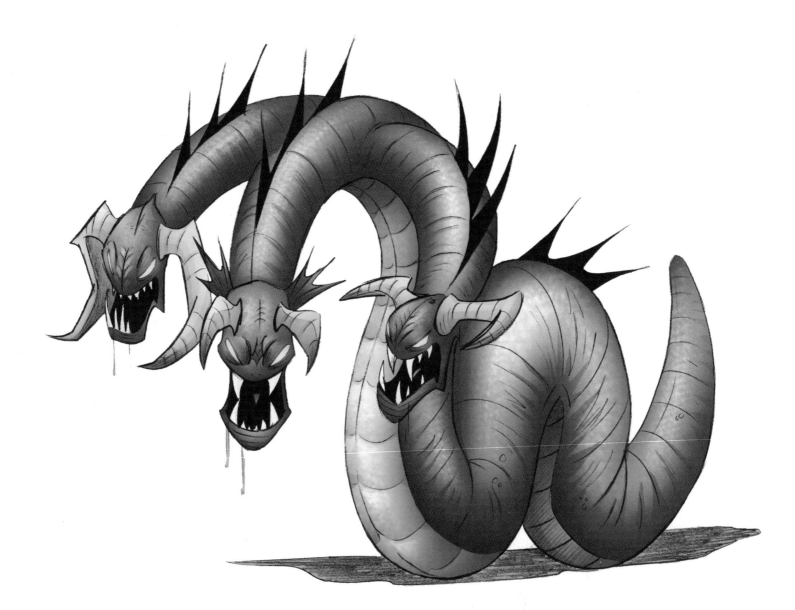

BEHEMOTHS: USING SCALE FOR IMPACT

How can you make something look big or even awesome? There are many effective ways. You can choose an angle looking up at the subject—and one in which the bottom of the subject appears wider than the top. You can have your subject cast shadows on the ground beneath it (a wide cast shadow gives the feel of a large presence). You can draw a thick body. And you can used dark, bold lines.

But, the most important technique of all has nothing to do with the size of the main subject. It has to do with setting up a comparison between the main subject and a smaller secondary subject that you place next to the main object. You place something of an instantly recognizable size next to your giant subject so that a size comparison is immediately understood. In the final drawing in this example (on page 95), you know that an average person is between five and six feet tall. Making the people so miniscule compared to the behemoth, enables the eye to immediately grasp how truly amazing the behemoth's size is. It's astoundingly huge. Contrast makes for good drama here as we realize that it's the small humans who are in total command of the large buffalo/camel/bighorned-sheep beast.

Note that if you were to use rocks as the secondary subject, instead of people, the behemoth's size wouldn't be so clear because rocks can be any size. One person might view the rocks as pebbles, while another might see them as large boulders. So again, your secondary subject must have an instantly recognizable size, perhaps a tree or a hut.

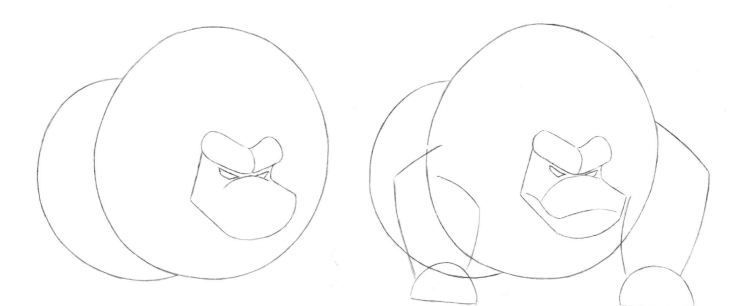

GENTLE BEHEMOTHS

Behemoths were so big they could carry entire villages on their backs. They weren't meat eaters (they had the rounded hooflike nails characteristic of vegetarian beasts, not the sharp nails of carnivores), and could go two weeks without drinking water because they stored it in their humps. Nomadic peoples of the North used behemoths when they trekked across the Flatlands in search of fertile grounds. Interestingly, behemoths came to work with humans quite by accident. Usually, this occurred when a behemoth was a baby and its parents were killed by a pack of dragons. It would be orphaned and on the verge of death. Since it wasn't a carnivore and, therefore, wasn't a threat to humans, nomads would save it. Nomads treated their behemoths with such constant care that, in turn, the behemoths would become devoted members of the clan.

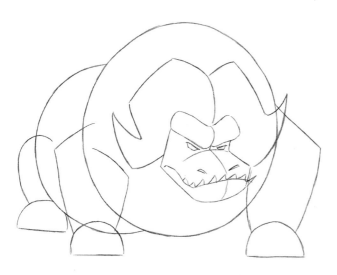

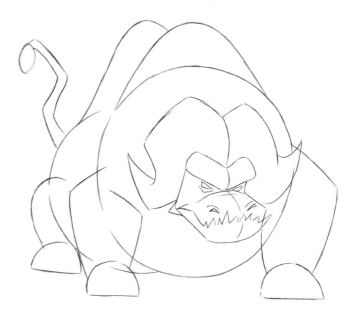

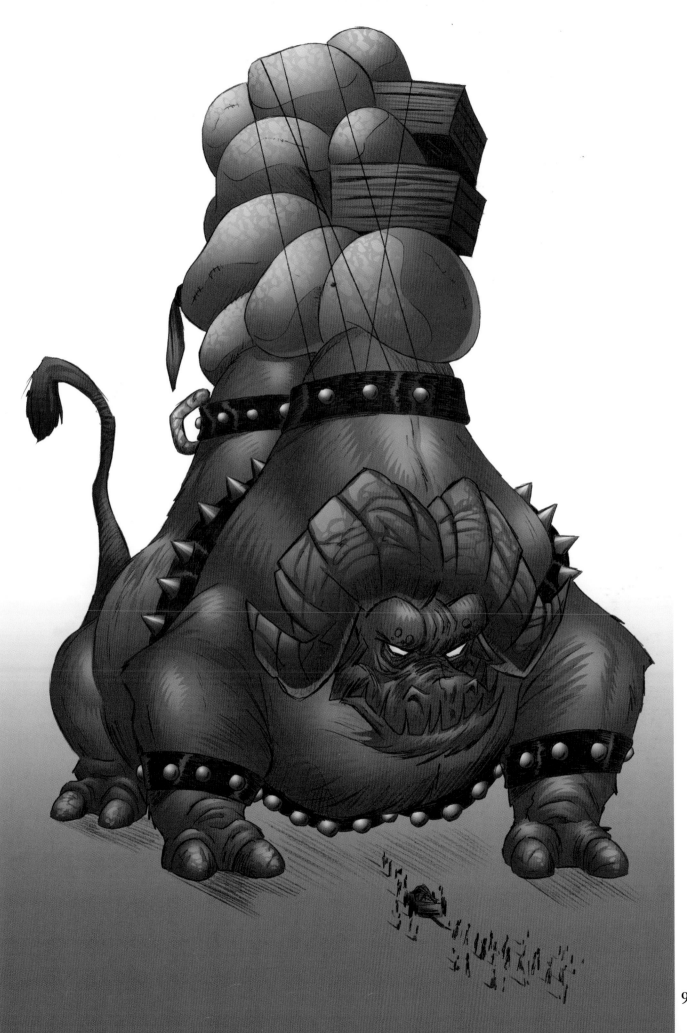

VI

DRAGON HUNTERS

It has been said that the history of mankind is the history of warfare. But this was not always so. For generations before the dragons migrated into their hemisphere, humans were peaceful. And there was plenty. Then the dragons arrived, the onslaught began, and the dragon hunter emerged.

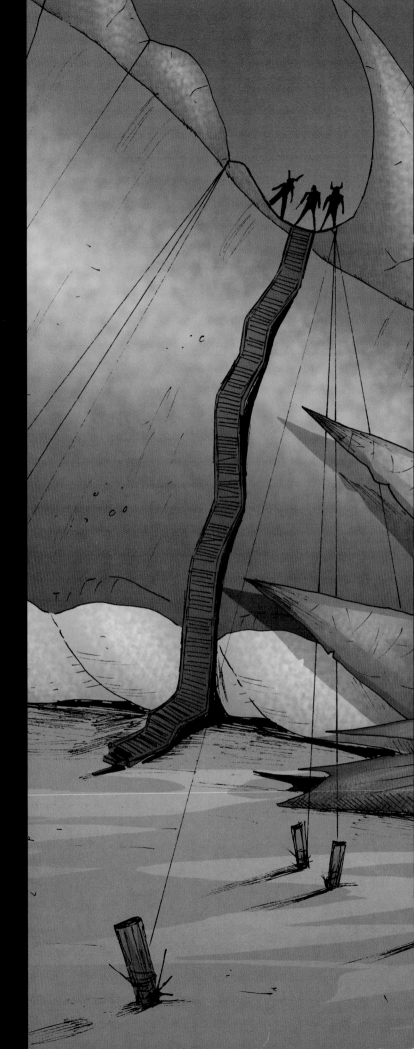

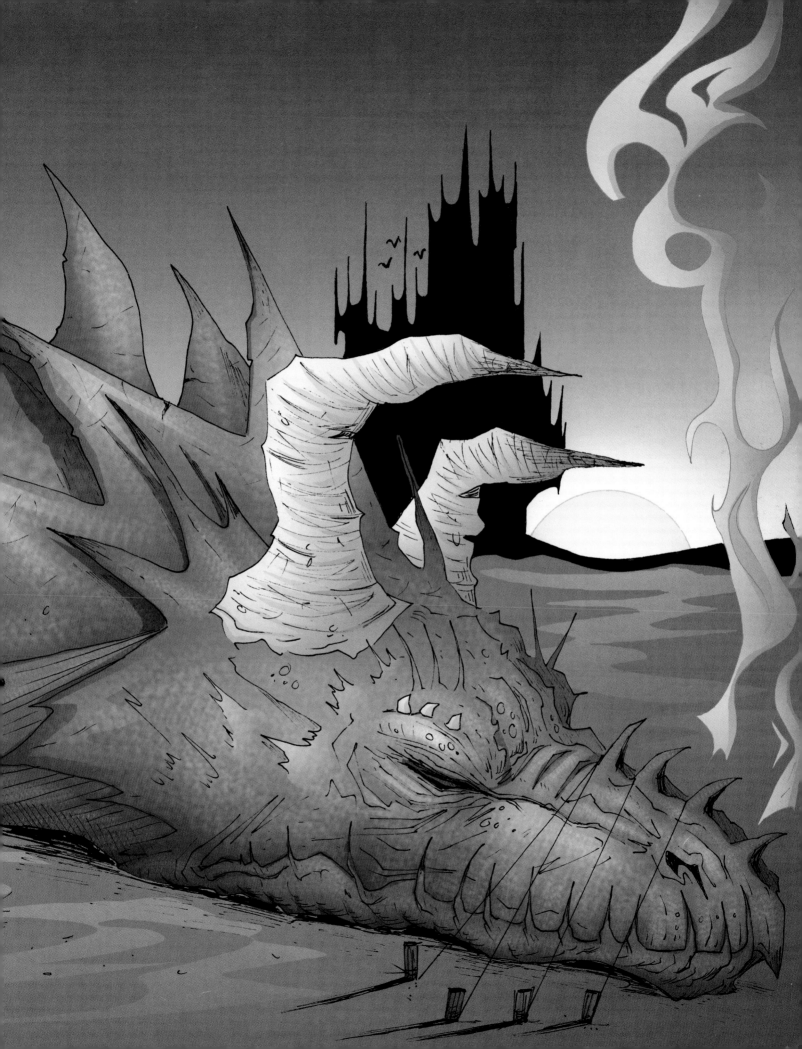

THE ERA OF TERROR

One by one, entire populations succumbed to the dragon. Villages became infernos. Entire towns were wiped out in a single day. The previously joyful people cowered in terror and lived in fear. They hid in dank caves and shielded their children from the sunlight, lest they be spotted by the ever-searching eye of the dragon. No amount of vigilance—regardless how great—could stop the slaughter. With their end in sight, these early villagers had an achingly difficult choice: to abandon their peaceful ways and take up the way of the warrior, or to remain true to their ideals and die as they lived, nonviolently. They chose the way of the warrior.

Secretly, they began to gather in groups of twos and threes, sharing observations, planning strategies, and, most of all, building weapons and training the young in the ways of violence. Survival depended on killing the beasts. So, their peaceful way of life was already gone. Their very existence itself now hung in the balance. The bowmen were the first to score kills. Archers had but one chance for a successful strike: a direct hit to the soft spot just below the pit of the dragon's neck. A moment's hesitation was fatal.

In addition to his longbow and arrows, the archer carried a large sword that required two hands to maneuver. In his pouch, he stored tools for sharpening arrowheads. And he completed his complement of weapons with *bolas,* which were throwing weapons made of weights on the ends of attached cords designed to capture animals by entangling their legs. With a skillful throw, bolas could also be entwined around a dragon's muzzle, momentarily preventing it from opening its mouth.

THE SWORDSMAN

A well-trained swordsman, if he's expert enough, can use swift, precise moves to repel a dragon's attack. One word of caution: There's no second attempt if the first strike fails.

In this defensive maneuver, the swordsman leans back on one knee as he creates a long, sweeping motion with his sword, slashing at the dragon above him. If he can cause the dragon to recoil, he may give himself just enough time to get to his horse. The arching line of the sword has to be at least one sword length high over the swordsman's head in this pose. The slash lines that indicate the path of the blade should be more concentrated near the tip of the blade and more scattered at the tail end (the starting point) of the path.

Arc of slash line

One sword length

Curved lines at top of chest and waist

Underside of jaw

Draw his long hair blowing to one side for a heroic look.

SHIELDS AND FIRE

Swordsmen also carry shields, which must be large and rounded to deflect the dragon fire. The flames must look powerful, forceful. To achieve this, use two drawing techniques: First, show the flames ricocheting off the shield. Second, and perhaps more important, show the force exerted on the figure—this is what best conveys the intense pressure of the flame.

Flames ricochet off shield.

Sword tilts up in fighting position.

Arm is locked.

Figure pushed into ground by force of flame.

The force of the flames pushes the figure down into a crouched position. The swordsman must hold the shield with a locked arm, away from the body, or he will be blown away. By drawing the shield out in front of the man, you give the image critical "breathing space." Bringing the shield in close to the figure would clutter up the image, and make it appear less heroic and statuesque.

Ordinary shields only work for limited periods. Dragons simply outlast them, since swordsmen can't hold them up under the intense pressure for more than a few moments. So, the villagers reinvented the shield, creating a unique style that was inside out. This reverse-curve shield deflects fire more efficiently and takes less strength to hold. It can withstand an entire bellyful of fire. Although it was only an incremental advance in the war against dragons, it was the first breakthrough in weapon development. When you use this shield in your images, draw the figure so that his upper body leans into the flame at a full 45-degree angle. Push his shoulders forward. It may seem counterintuitive, but in order for the flame to appear powerful, the figure must meet the flame with an equal amount of power.

Exterior

Exterior handle

Bottom tip digs into ground for support.

SPEARS

Spears appear in many exciting images of dragon battles. These weapons conjure up prehistoric cave paintings of cavemen fighting woolly mastodons. Those pictures were powerful and dramatic. It was David and Goliath, but in a different form.

Slowly, almost imperceptibly at first, the tide began to turn from trying to stave off the withering attacks of dragons to actually hunting them. This developed further with the invention of powerful poisons that were applied to the spear tips (and to arrowheads, as well). The poisons were fast acting—but only effective on certain species of dragon. And many difficult-to-acquire ingredients were required to produce only a very small quantity. Nonetheless, for the first time ever, they allowed the prey to become the predator. Dragon hunters would attack dragons in packs of three or four men. Their spears enabled them to fight from a distance or even from above if they could find a good hilltop position.

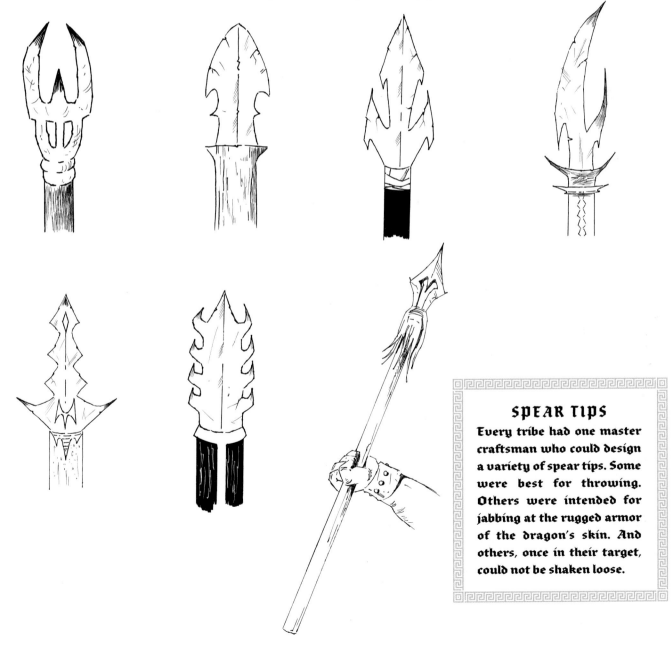

SPEAR TIPS
Every tribe had one master craftsman who could design a variety of spear tips. Some were best for throwing. Others were intended for jabbing at the rugged armor of the dragon's skin. And others, once in their target, could not be shaken loose.

ONLY THE BRAVEST . . .

Only the bravest warriors could work their way this near to a dragon. Once its prey was close, the drag-
on could not dodge and weave. Instead, it would attack. It would raise its razor claws to take out a man
with one slash. The warrior had but one chance—and it was a small one at that. He had to draw back
his spear and, in the instant the dragon paused to marvel at the audacity of its small foe, take his shot.

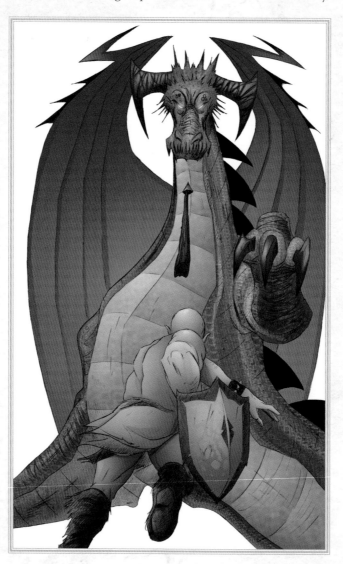

SCENE CONSTRUCTION WHEN
ONE MOMENT IS ALL THERE IS

In this composition, you're looking over the warrior's back, up at the great beast. By placing the reader's point of view behind the hunter, you reinforce the idea that the reader is like the warrior. The dragon is not just facing the hunter but also the reader. This composition forces the reader to relate intimately to the drama of the scene. It forces the reader to choose sides.

Another technique drawing the reader in here is the use of forced perspective. The man's elbow has been somewhat exaggerated in size as it points toward the reader to add impact. In fact, the entire figure is either coming at you or moving away from you, which is the essence of dynamic posing. Nothing is staged in a side view. Side views can be pretty, but they're rarely very involving because they don't pull you into the scene.

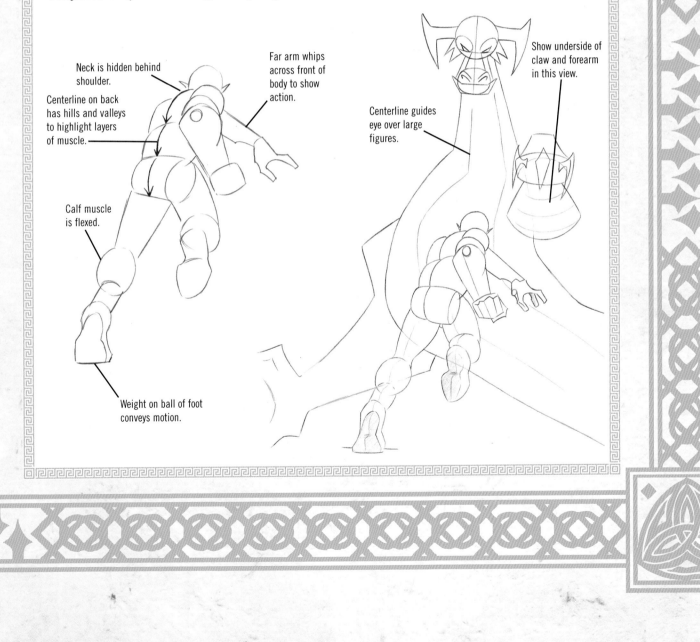

Neck is hidden behind shoulder.

Centerline on back has hills and valleys to highlight layers of muscle.

Calf muscle is flexed.

Weight on ball of foot conveys motion.

Far arm whips across front of body to show action.

Show underside of claw and forearm in this view.

Centerline guides eye over large figures.

FEMALE WARRIORS

The female warrior is an interesting character type. She is often a combination of a primitive princess and savage fighter, and this makes for a ruthless—yet alluringly beautiful—woman, passionate and untamed. As the battles between man and beast became ever fiercer, more female warriors joined the struggle.

When drawing female warriors, you must use body proportions that convey strength, sex appeal, and beauty. Wide square shoulders, a narrow waist, and wide hips are all key.

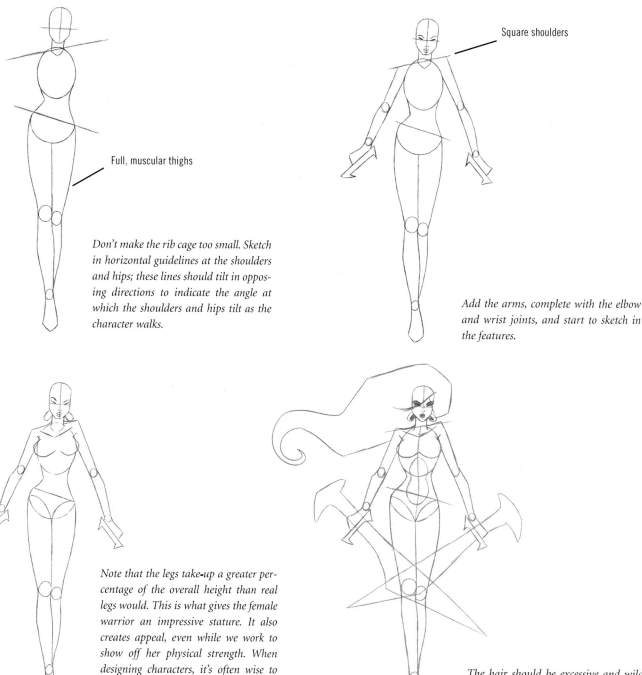

Full, muscular thighs

Don't make the rib cage too small. Sketch in horizontal guidelines at the shoulders and hips; these lines should tilt in opposing directions to indicate the angle at which the shoulders and hips tilt as the character walks.

Square shoulders

Add the arms, complete with the elbow and wrist joints, and start to sketch in the features.

Note that the legs take-up a greater percentage of the overall height than real legs would. This is what gives the female warrior an impressive stature. It also creates appeal, even while we work to show off her physical strength. When designing characters, it's often wise to play one attribute against another, in this case power versus feminine appeal.

The hair should be excessive and wild. The swords should be oversized, intricate, or gothic.

Note how all the details conspire to create an effective image: the square shoulders, the shoulder/hip directions, the hourglass curve of the torso, the contours of the abdominal area, the joints punctuating the limbs, the long-legged proportions. The eye doesn't necessarily have to be aware of all the specifics, but will just feel that the drawing works.

THE NECKLACE

The female is often a lone warrior, undertaking difficult journeys solo, across many miles of forest and brush. To find her way home, she brings a map with her, which she keeps on the reverse of the medallion on her necklace.

WOUNDING THE DRAGON

Perhaps the most dangerous thing a hunter can do is wound a dragon but not kill it. There's no beast of darkness more vicious—or more ferocious when injured—than the dragon. When striking a dragon, a hunter has only one shot, otherwise the dragon's revenge is swift and sure.

A direct hit to either the shoulder, elbow, or knee joint will slow a dragon. However, it takes multiple hits to these areas in order to seriously degrade a dragon's fighting abilities. The dragon will surely kill the first few hunters who land spears or arrows into these spots.

KILL POINTS

There are only three absolute "kill points" on the dragon, and they all lie on the soft underbelly of the beast. They are the underside of the jaw, the underside of the neck, and just below the sternum. If a shot is off only slightly, either to the left or to the right, it will only anger the creature. However, if dead on, a shot to a kill point results in a look of stunned disbelief in the dragon's eyes, followed by a short gasp, the convulsing of the body, and, finally, a collapsing to the ground.

Dragons may have been large, but they were quick, twitchy creatures, always in motion, irritable, and instinctual. They were difficult to hit with an arrow or a spear anywhere on the body, let alone on a specific kill point. They would dart out of the way and often swat arrows and spears with their tail, like so many annoying flies. Killing a dragon in flight was the most difficult feat on earth. It's the equivalent of intercepting a missile from the sky.

DEATH OF A DRAGON

Once an arrow hit a kill point, there was nothing a dragon could do, and death came swiftly. The moment a dragon was hit in a kill spot, men and women would run for their lives because the gigantic beast would fall with the weight of a dozen redwoods, flattening everything underneath it. Men who had been victorious in battle would, nevertheless, lose their lives when they were unable to escape a dying dragon as it fell to earth.

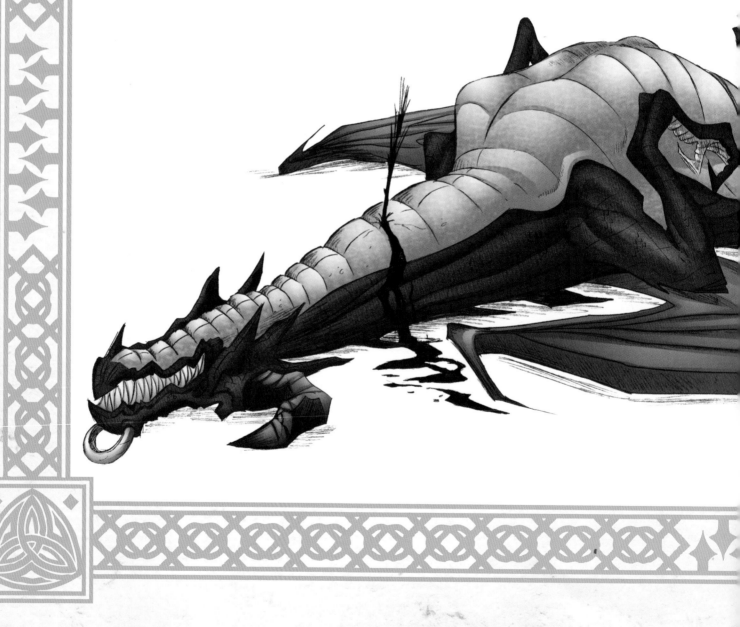

SUCCESSFUL FANTASY STORYTELLING: MORE THAN GOOD VS. EVIL

There are keys to weaving satisfying stories and drawing heroic fantasy scenes, and you're handicapping yourself if you don't make use of some of these effective themes: *Good vs. evil, Huge vs. small, Light vs. shadow,* and *Invincibility vs. mortal weakness.*

Heroic fantasy is most poignant and effective when it contrasts two opposite ideas. This isn't so much a drawing techniques as it is a story technique. Fantasy illustration, more than any other form of popular imagery, is about telling a story from single images. The classic *King Kong* is a stellar example of this. It makes use of all the opposing characteristics just mentioned: *Good (the girl) vs. evil (Kong), Huge (Kong) vs. small (the girl), Light (the girl) vs. shadow (Kong),* and *Invincibility (Kong) vs. mortal weakness (the girl).*

Not all of these elements will be at play in every heroic fantasy scenario, but often, one or more is. Examining the scene here, the fallen beast lies on its back. The first contrast is the huge size of the dragon versus the small arrow. David felled Goliath. That's drama. It's not dramatic when a giant beats up the little guy. The second contrast is, of course, good versus evil.

MACHINES: THE GREAT LEAP FORWARD

The constant challenge in dragon hunting was how to bring down the terrible beast while it was airborne, when it could wreak the most havoc. Out of the range of most archers' arrows, the dragon could unleash fire upon villages at will, doing untold damage.

Villagers reasoned that if they could prevent the dragon's wings from functioning in midflight, the dragon could be taken down. To this end, they built a catapult that would launch a huge chain mail net. The net covered the dragon in flight and brought it down.

Chain mail net

Weights keep net open.

Launcher

Release mechanism

Coil

THE ADVANTAGES OF THE NET

Unlike arrows, which could easily miss their target when launched from the ground, a net covered a wider area and was, therefore, difficult for the dragon to evade. As the net would overtake its mark, the dragon's wings would become trapped. Unable to maintain altitude, the dragon would begin its inevitable downward spiral. As it tried to dig out from under the netting, it only tangled its wings further. And, once the flying leviathan met the ground, it hit with so much force that it shook the earth for hundreds of kilometers in every direction. Villagers had only moments to secure the creature before it woke. Many cables would be fastened tightly to the ground (see page 97). Once in place, the beast was at their mercy.

MEN TURN DARKER

As men finally achieved parity in their long war with dragons, many voices called out to remind men of their original, peaceful credo. With their existence now assured, many wanted to turn back the clock and again become the harmonious people they once were. But as the genie, once released, is difficult to put back in the bottle, so are the ways of violence hard to reverse. The power of victory was like a drug and had given rise to evil among men. The darker forces spurned the cry for peace as one of weakness. These darker forces now vowed to hunt the dragon into oblivion.

One tool in this quest was the spike launcher, a particularly effective and brutal machine. This evil machine could be moved around as needed. Cruelly adopted by the darker forces of man, it was used to excess. One by one, the dragons succumbed to its lethal accuracy. This so offended the consciences of the good people of the villages that they joined forces to see what they could do to stop the carnage. For a people who were once almost driven to extinction by dragons, they were now considering coming to the aid of the very creatures that had all but decimated them. It was a strangely ironic turn of events, but the conscience of good men does take measure of ironies. And so it was decided. They would fight to preserve the dragon. This split mankind into two factions: the forces of good and the forces of darkness. So it was, then and forevermore. And today, even though the dragons are no more, these two forces do battle still.

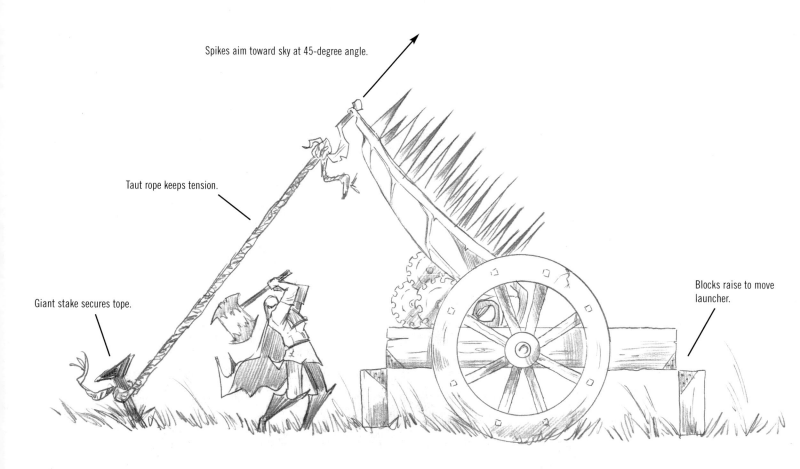

Spikes aim toward sky at 45-degree angle.

Taut rope keeps tension.

Giant stake secures rope.

Blocks raise to move launcher.

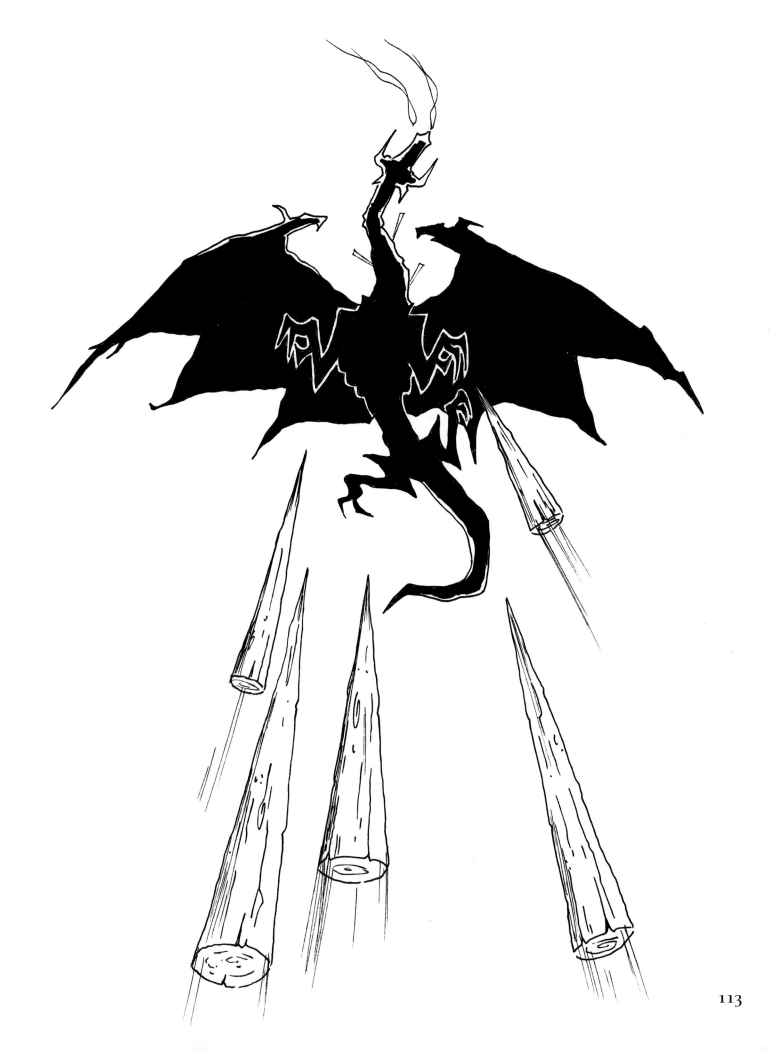

POACHERS

Fueling the drive toward dragon extinction was man's appetite for dragon meat, which quickly became a delicacy among the previously agrarian society. Nomadic hunters discovered that they could quickly become fabulously wealthy with enough dragon kills.

Sometimes, a scene calls for your character to simply stand there, as with this dragon poacher cooking some dragon meat. But it's not always a good idea to just leave a character static, especially when it's a dynamic and athletic one, as the poacher is. There are ways to transform a relatively inactive standing pose into a dynamic one. Take a look.

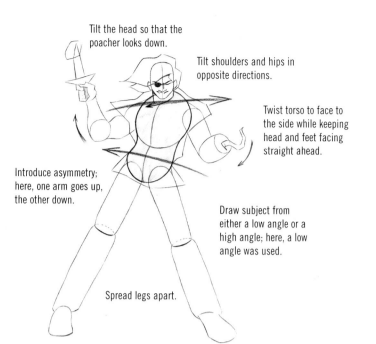

Tilt the head so that the poacher looks down.

Tilt shoulders and hips in opposite directions.

Twist torso to face to the side while keeping head and feet facing straight ahead.

Introduce asymmetry; here, one arm goes up, the other down.

Draw subject from either a low angle or a high angle; here, a low angle was used.

Spread legs apart.

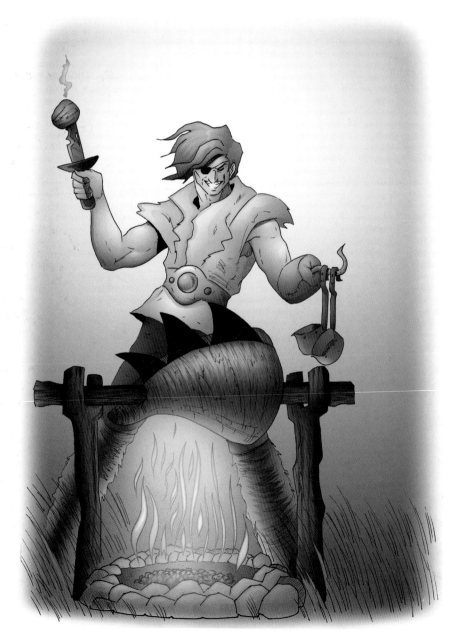

TRADERS IN DRAGON PARTS

Ah, yes, traveling salesmen. They were ubiquitous in the time of the dragon, as poachers sold off parts of their kills. Dragon horns were said to possess miraculous medicinal properties. And where there are desperate people demanding cures, there is money to be made. Roving salesmen entered villages, set up their wares, and quickly sold as many things as they could before getting kicked out by the local guardsmen. Then, they moved on to the next town with a pocket full of gold. And woe to the townspeople who were fooled by their charms and "low" prices. None of their nostrums worked. Some of their items were stolen; others had been created by artisans looking to turn a quick profit. But worst of all, some salesmen brought the plague with them from the previous stops on all their travels.

A NOTE ABOUT THE POSE

Unlike the standing pose on the previous page, this one has no dynamic body twists and turns. And yet, you can't say that this is an uninteresting scene. So, does this mean we don't need techniques for dynamic posing after all? Well, it's really a bit more complex of an issue than that. Perhaps the rule—if there should be a rule at all—is: Let the material (the subject matter) inform the process. Simply put, would your character benefit from a lively pose? When you consider this character, with the huge animal skin covering him, a dynamic pose doesn't seem like a good choice. He doesn't need it, and he can't use it. His rugged costume and his charisma are the keys to the scene, not his body language.

Similarly, a fat king character would need less body language than his court jester. The king's crown, robe, beard, and overall stout physique should be enough to make an impression. We don't expect a portly noble to bend and twist. The jester, however, is a stereotypically hyperactive character type, and therefore, a goofy pose is much more important in defining his character.

DRAGON "TRAINING"

As man's evil nature grew, some decided that, with their superior weapons, they could now be masters of the dragon. Countless vain attempts were made to train the beasts. How shortsighted their lust for power made them. No amount of shackles or inducement could break the savage nature of the dragon.

Unable to control even the most heavily chained dragons, these dragon "trainers" had to eventually release or kill all of the beasts they captured. However, more than half of the time, the dragons broke free first, wiping out their "masters."

A nicely curved line of action provides a good base for a pose.

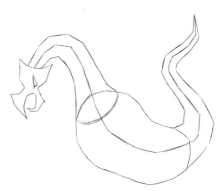

The body construction follows the line of action.

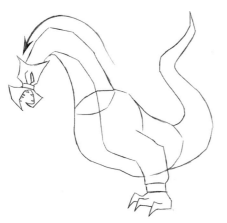

The neck muscle becomes the line of the shoulder.

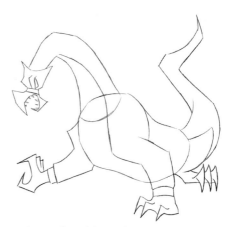

A strongly arching neck conveys power.

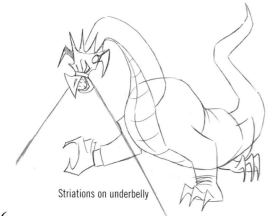

Striations on underbelly

Allow no slack to show in the chains. The tethers must be taut, otherwise it will look as though the dragon isn't truly restrained—isn't pulling against anything. In addition, "squeeze" the face where the strap wraps around the muzzle.

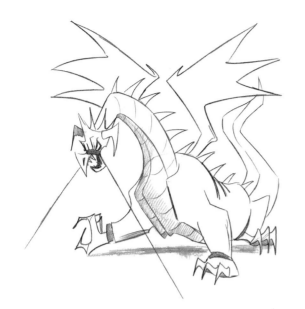

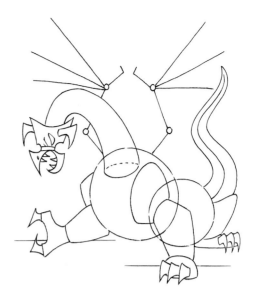

Sketch a contour line down the middle of the tail. This is where the dorsal plates will attach.

Sometimes, it's useful to see a single, simplified diagram of a drawing, in addition to a series of step-by-step constructions.

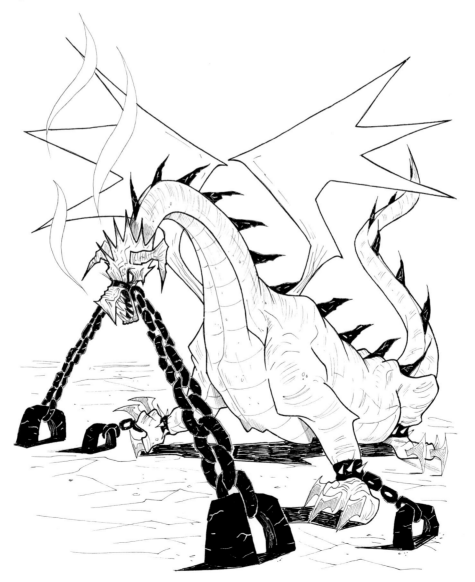

THE CULT OF DARKNESS

As the remaining dragons retreated to faraway mountaintops, they left a vacuum of power that was filled by the evil of man. The Cult of Darkness descended. Strange beings spread throughout the land. Death followed in their wake. A great plague was upon them. The Cult of Darkness gave rise to mutations who were half-man, half-demon. They flourished for a time in the madness that ensued, when every day seemed like the end of the world. The skull collector was one of these mutants.

When drawing half-man, half-demon mutations, don't go over the top with the mutant elements. These characters are still basically men—just very evil men. Their mutations simply symbolize the evil in their souls, which is the most dangerous evil out there—worse than horns.

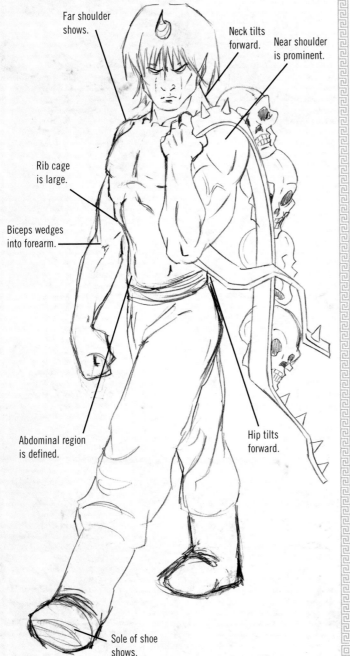

Far shoulder shows.

Neck tilts forward.

Near shoulder is prominent.

Rib cage is large.

Biceps wedges into forearm.

Abdominal region is defined.

Hip tilts forward.

Sole of shoe shows.

INKING

When you compare the pencil version of this image to the inked (and colored) version opposite, you can see that more than just the ink and the color make the difference. Inking is not simply a matter of tracing the pencil drawing. It is also about making choices.

Inking it gives you a second shot at the work—a chance to look at it from a new perspective. You can leave out the lines that now seem extraneous or superfluous. You can thicken important outlines. You can add shadows and pools of black to areas that you had previously left empty. And, you can open up areas that were too busy with light sketch marks. An ink line is bold. It will sometimes make other lines appear redundant. You may, therefore, want to eliminate some lines you had previously thought were essential.

Don't trace every single line with the precision of a surgeon. Let yourself be spontaneous, to suddenly extend a line in a direction you hadn't quite planned on if the feeling moves you and if it seems like the right thing to do.

NORSEMEN

Nordic conquerors are a particularly popular character type, especially in fantasy illustration or other genres in which epic battles are fought. They are deeply rugged and hardy. They flourish in the frozen arctic tundra. They're most often depicted on horseback, or on some other strange large creature, and wear either Viking or medieval knight helmets, or a blending of the two.

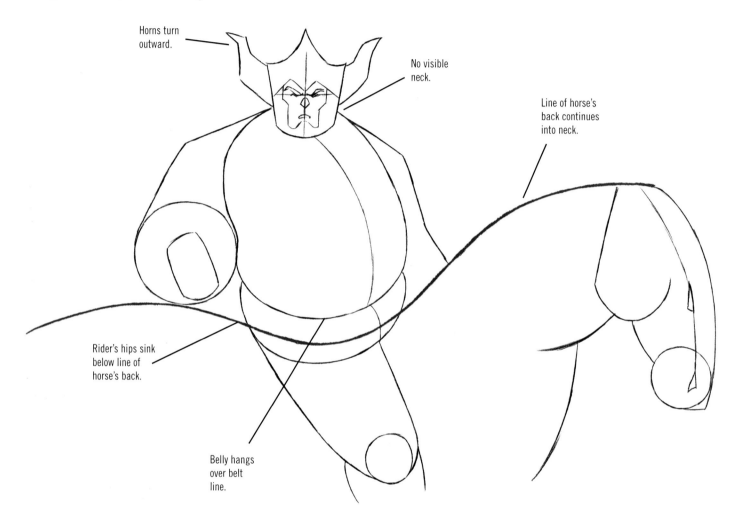

Horns turn outward.

No visible neck.

Line of horse's back continues into neck.

Rider's hips sink below line of horse's back.

Belly hangs over belt line.

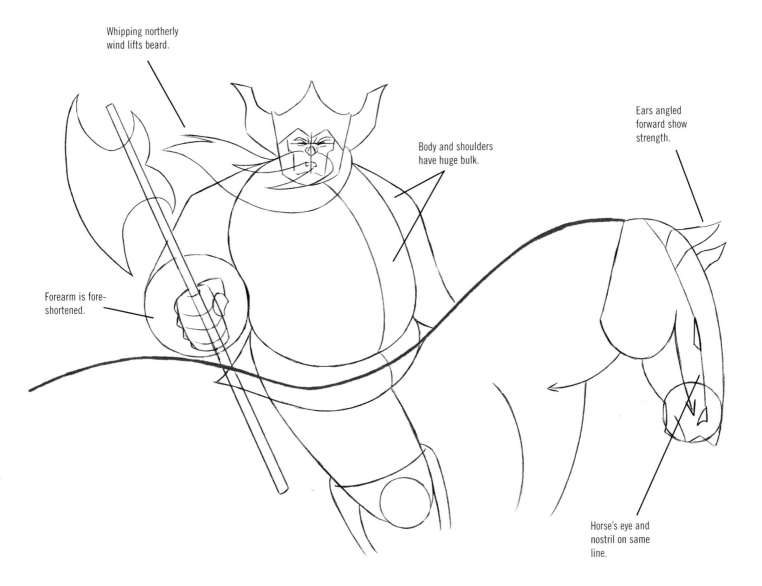

Whipping northerly wind lifts beard.

Body and shoulders have huge bulk.

Ears angled forward show strength.

Forearm is fore-shortened.

Horse's eye and nostril on same line.

DRAWING CHARACTERS ON HORSEBACK

Artists who can otherwise draw excellent characters—and excellent horses—nonetheless sometimes find it a challenge to draw a figure on horseback. To help, keep this in mind: The rider doesn't sit on top of the horse, the way a person sits on top of a chair. The rider's hips always sink *below* the line or level of the horse's back, as shown on the diagram.

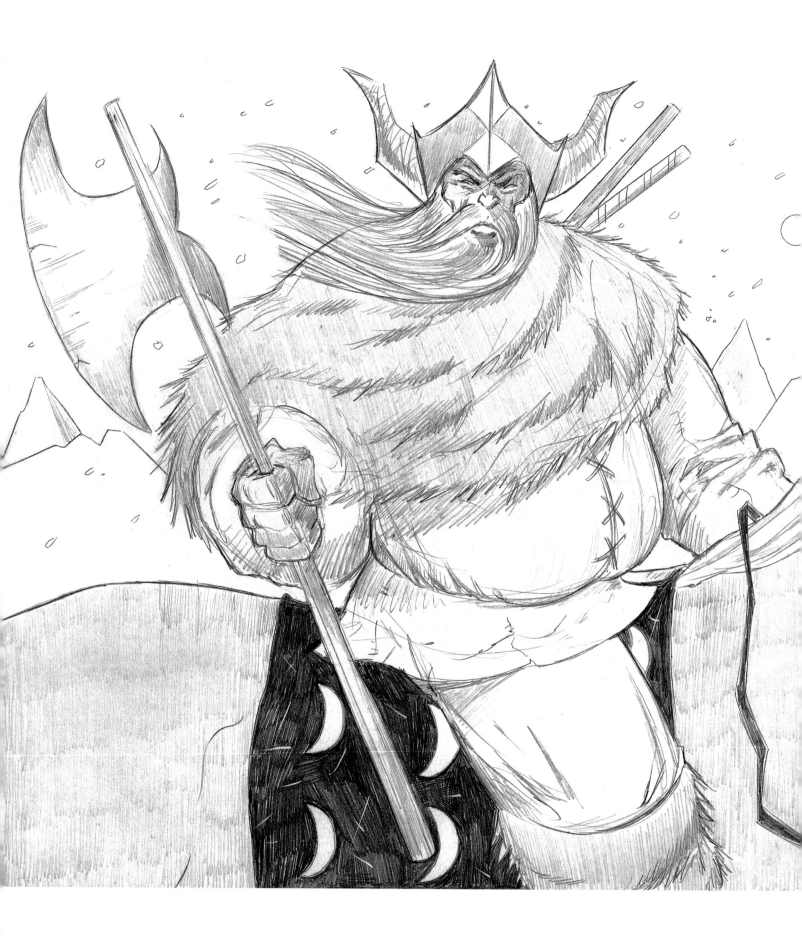

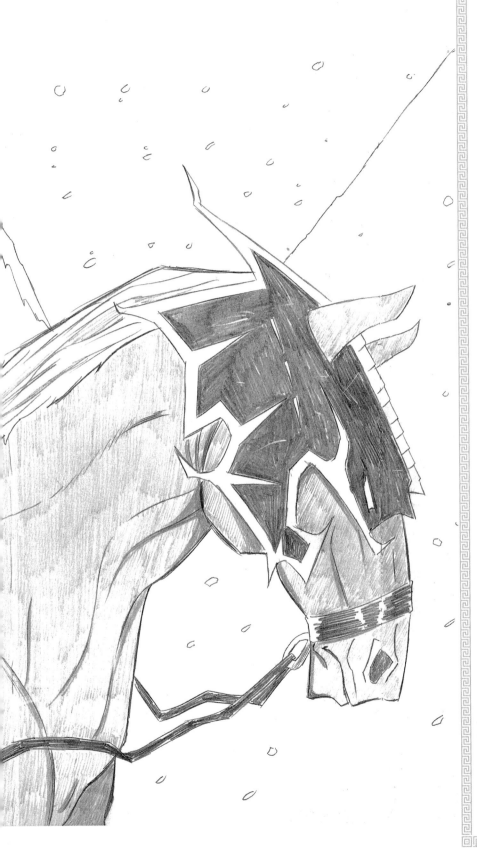

MOOD, ATMOSPHERE & PROPS

A blurry, snow-specked sky. An empty landscape, without a tree in sight. Snowcapped mountain peaks as far as the eye can see but no civilization in sight. A long axe. Setting a scene isn't about filling the background up with as many details as you can. It's about reminding readers where they are by making the wisest, most economical choices. Be frugal with your backgrounds and props. Give only as much information as is absolutely necessary. Readers don't want to see tons of background details. They want the background to give them a *general* feeling of the environment.

The scene here screams *cold and bleak*, and yet, there's a paucity of background "props" (and actual props, for that matter). The emptiness itself is evocative. You don't need to draw dozens of boulders of snow to convey the point. The emphasis today, in fantasy illustration, is away from overworked, busy backgrounds. The key to remember: You *suggest* a background, rather than *render* it.

Similarly, there are only so many props readers can absorb when looking at a picture. Choose fewer props—but more significant ones. Here, we have the prominent long-handled axe, the Viking helmet, the fighting sticks on his back (which may be the handles of long swords or spears), the horse's helmet (which gives the animal a severe persona), and the most character-creating prop of all: the bearskin wrapped around his shoulders. All of these have a consistent theme: They're essential to the Norseman's survival. They're all functional. This is typical of heroic fantasy illustration, as opposed to science fiction illustration in which nothing looks functional or essential and everything appears overly complex.

WHEN GOOD BATTLES EVIL

Men don't only fight dragons; they fight one another. The young are brave and foolish. The evil are so much stronger. And still, young warriors continue to fight. Will they be defeated? Perhaps. Perhaps not. But even if they lose their struggle, it won't be for long. For even through the darkest of nights, nothing can stop a heart that's true.

Unfortunately, though armor is a great protector, it can also be the Achilles' heel of a knight. Once fallen, the knight cannot right himself without great effort or the help of his comrades. A simple wound that causes him to fall on his back during battle can prove a mortal blow, whether or not the injury itself is actually fatal.

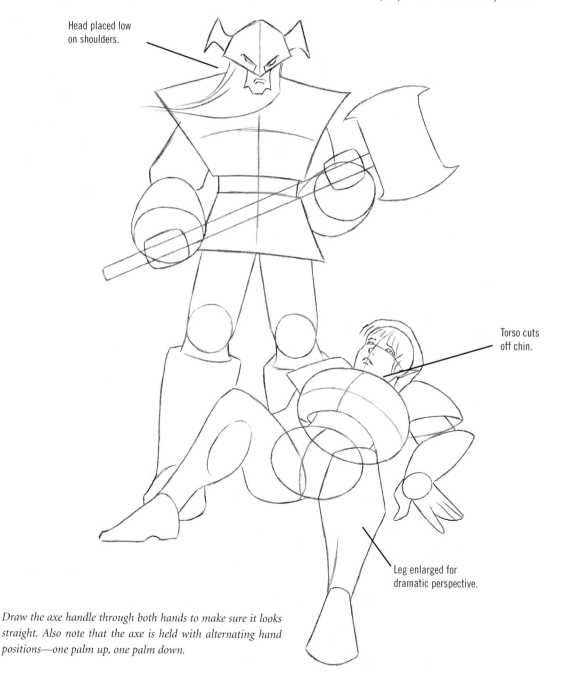

Head placed low on shoulders.

Torso cuts off chin.

Leg enlarged for dramatic perspective.

Draw the axe handle through both hands to make sure it looks straight. Also note that the axe is held with alternating hand positions—one palm up, one palm down.

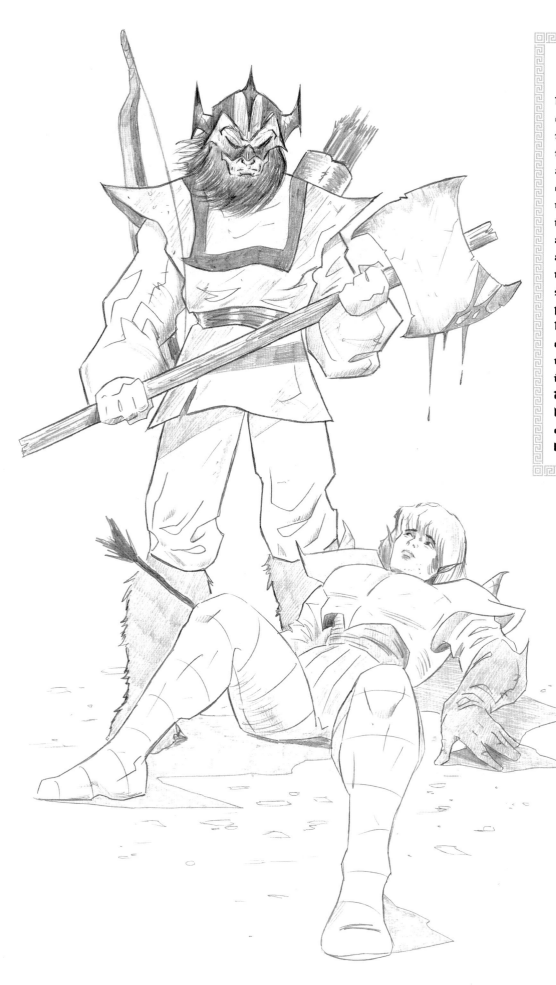

WORKING WITH PENCIL

Note the various tones you can achieve from varying the pressure you apply to the pencil. Pencil gives you a more nuanced and expressive line than ink, while the boldness of the ink line lends itself to the addition of color, which also has intrinsic excitement that's expressive. The subtleties and flexibility of pencil work well here. Light pencil work helps convey the furriness of the villain's boots, while heavier pencil keeps his face in darkness. Typically, the villain's face is cast in shadow, while the hero's face is bathed in light.

THE RETURN OF
THE DRAGON

Today, while mankind has forgotten its past and continues on its path toward progress, the dragon has been biding its time. The King of Fire is a patient beast. It is still out there, in the mists of the mountains, near the top of the world, watching and waiting. Right now, it is birthing a new generation. Soon, it will be teaching them how to hunt, and all that it has learned about the treacherous ways of men. And this time, we won't get off so easily. You see, dragons, like men, can also learn. And they never forget.

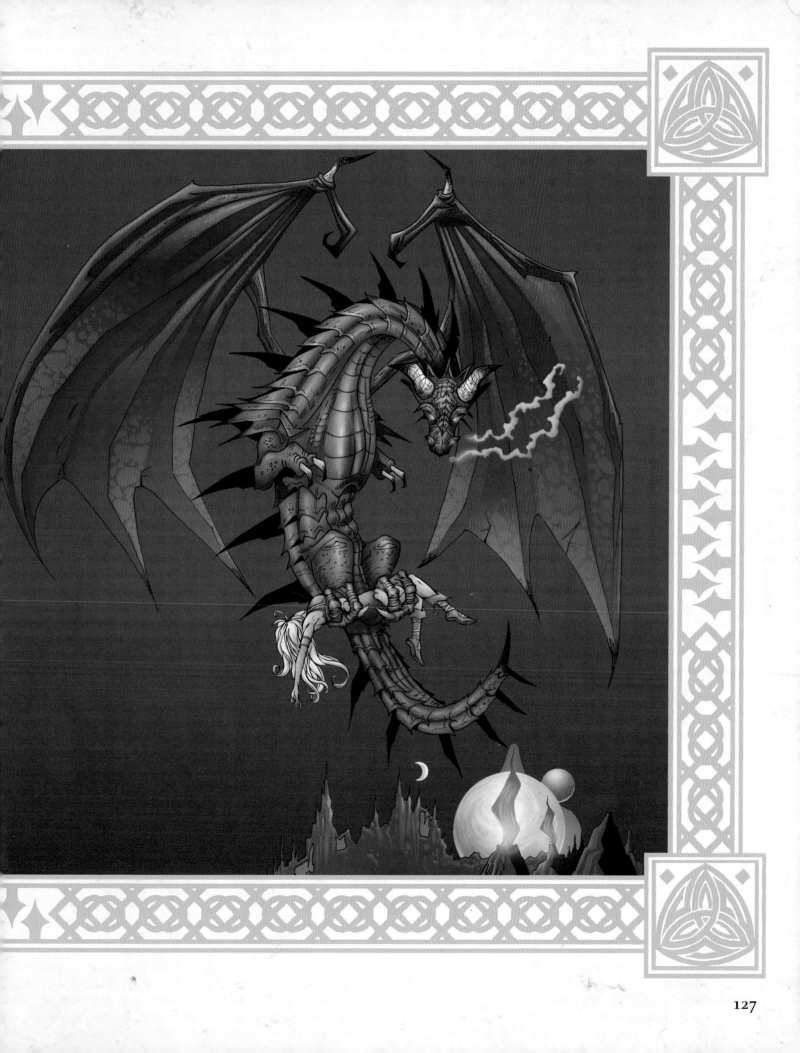

127

INDEX